Contents

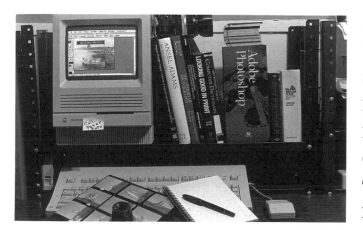

Preface

Opportunities for today's freelance photographer abound in the age of information. Publishers seek images to fill newspapers, magazines, books, and electronic media. Corporations and institutions need pictures to promote their product or service. And because the scope of the market is so wide, the kind of photography you like to do probably has a market. The Freelance Photographer's Handbook will help you identify photo markets and prepare you to get work.

Making good photographs and selling them require different skills. The successful freelancer must learn both. The Freelance Photographer's Handbook shows you how to sell to major publication markets: corporations, institutions, magazines, newspapers, stock picture agencies, textbooks, and electronic media such as television. This book provides a plan for you to follow, providing tests, forms, cutouts, and motivation.

Through self-evaluation tests and photo market analysis, the Handbook helps the freelancer find the connection between personal interests, skills, and existing markets. Portfolio guidelines, essential equipment, and ideas for local assignments get the beginning freelancer started in the photography business.

The Freelance Photographer's Handbook breaks down major photographic markets into: 1) scope and nature of the market; 2) photo needs; 3) how to break in; 4) portfolio requirements 5) prices and terms; 6) client's perspectives on the market; and 7) directed assignment. Every directed assignment is a carefully chosen photo shoot designed to give the photographer a taste of what working in that particular field is like, while simultaneously generating portfolio material.

Freelance photographers can increase profits from the sale of stock photographs—from their own picture files and through a stock photo agency. The Handbook explains how to set up and use your stock photo files, how to choose a stock agency, and tells you exactly what kinds of photographs are in demand today.

This book illuminates the ins and outs of model releases, copyrights, and how photographers can avoid unauthorized usage of their pictures. Office procedures, including stationery, mailing photos, invoicing, and keeping tax records are organized into easy to understand, time-saving systems. The Freelance Photographer's Handbook also examines computers, which have become an indispensable office and marketing tool, provided a means for electronic photo requests, and have also created their own market for photographers.

Persistence, photographic skills, and marketing know-how sell photographs. The Handbook shows how to use them together effectively. Whether your motivation is artistic or financial, The Freelance Photographer's Handbook will help you pursue a productive freelance career in photography.

Note to the reader: The discussion of tax and legal issues in Chapters 11 and 12 of this book are presented accurately, to the author's best knowledge, at the time they were written. Due to local variations, the complexity of the subject matter, and the frequency of changes in these areas, however, it is strongly recommended that you seek competent advice from a professional lawyer or accountant before making any serious decisions in these areas.

Author's note: Since the first publication of The Freelance Photographer's Handbook in 1981, I have stayed with the freelance business, watched it change, and grown with it. The industry of buying and selling photographs has evolved: new markets have opened up; improved tools are available for both shooting and marketing photographs; and rates have increased with the maturation of the market. I trust that this revision reflects what's new in freelancing, what I have learned, and my continuing joy in taking and selling a picture.

CHAPTER ONE
Being Freelance

The Joys of Freelancing

Photographic Directions

Where are You Technically?

Photographic Education

The Joys of Freelancing

Being a freelance photographer is fun. I work hard, I play when I can, but I wouldn't trade it for anything. Plenty of people enjoy full-time nine-to-five jobs. And plenty of people hate their jobs and would change their work if they could. That is the big difference between the staff employee and the freelancer: When you are your own boss, you can choose work of your own liking and, one hopes, enjoy it.

If you want to be a freelance photographer, you need to know two things: 1) how to take good pictures, and 2) how to sell them. The techniques of good basic photography, applied to carefully chosen subjects, create salable pictures. To make any amount of money, you must be productive, wise about business, and persistent. I know you're eager to hear about the romance and glamour of freelancing, but first let's take a look at what freelance photography really is.

Quite simply, being a freelance photographer means that you own and operate your own business, just like a doctor or electrician. As a contractor of photographic services, you must line up jobs, deliver satisfactory work, and run the business to show a profit. If you don't do all these things, your business will flounder.

Freelancing can be full-time, part-time, or all-the-time. It depends on how hard you want to work. There are high school students and retirees who supplement their income with photography. The weekend freelancer can go full-time by expanding work for existing clients and finding new ones.

You have a greater chance of enjoying freelancing because you can pursue the field of photography that appeals to you. And if that appeal should fade in time, it's not so difficult to switch over to a related field. Many freelancers have a variety of clients. They rarely have a dull moment with this arrangement; if one type of work slows down, the others usually take up the slack.

The real joy of freelancing—the ace in the hole for most of us in this profession—is the love of photography. I would take pictures anyway, even if I had to do something else for a living. If this sounds like you, you're right for freelancing.

If You Like It, Shoot It!

When a photographer for Stock, Boston asks the agency's owner, Mike Mazzaschi, what to shoot, Mike's advice is for the photographer to shoot what he or she likes. Mike knows that when a photographer is intrigued by a subject, the results are good pictures—and lots of them. Good pictures sell. But when the photographer is bored, the pictures and the profits suffer.

The beginning freelancer, as well as the seasoned pro, should be constantly examining interests and goals. If you shoot what you like, you'll have some important factors working for you:

Knowledge: Chances are you'll already have some familiarity with a subject you're personally interested in. Learning more about it will be a pleasure.

Motivation: The drive a photographer needs to start a job and see it through. Money is not always enough.

Inspiration: That elusive artistic ingredient that helps the photographer think creatively, put some self into the pictures, and go beyond what's been done before.

Enthusiasm: Absolutely necessary to convince a client to hire you. Who needs a photographer who has no feeling for the subject?

I don't photograph kids for a living, but I like them—and my pictures reflect this. Christa's portrait was taken for fun and sells regularly.

Magazine

Textbook

Publicity

College Catalog

A freelancer sees plenty of variety. I enjoy exploring different situations and meeting different kinds of people in my work. Magazine, textbook, health care, and corporate publicity typify the freelance mix.

Even nature photos sell, if you like what you're doing and know how to market it. This shot of Crawford's Notch, N.H., sold twice as a regional magazine ad for New Hampshire. It has grossed over $2000.

Photographic Directions

The Interest Self-Test below will start you thinking about photographic directions, and there are many of them. First, read the Photo Markets Overview below to get a general idea of what's out there. Then take the test, and, for clarity, write down the answers. See if the kind of photography you want to do is similar to any of the markets in the overview.

Photo Markets Overview

I have listed the major freelance photo markets so you can see them all at once. Each one is explored in detail later in The Freelance Photographer's Handbook.

Weekly Newspaper: Local news, human interest, and community functions. Some weekend and night work, lots of driving. Pays from $5 to $20 per photo published. Uses black and white (b/w) almost exclusively.

Yearbook: School candids, events, groups, and sports. Can lead to public relations work for private school or college. Bank hours, with some after school. When assigned by yearbook company, pays $5 to $20 per hour. When contracted by the school, fee is negotiable and usually higher.

Weddings: Traditional poses and candids, from ceremony to reception. Weekend days and evenings. Studio pays freelancer about $100 per wedding, more if experienced. When freelancer books and shoots own wedding, profit ranges from $250 to $1,000 and more. Color only.

Publicity and Promotion: Head shots, desk shots, environmental and formal portraits, functions, products, and services. Business hours. Negotiable, from $25 to $200 per hour. B/w and color.

Daily Newspaper: Spot news (accidents, fires), community and government events, human interest, feature stories, and sports. Depending on paper, may travel to cover national news. Hours may be erratic. Rates vary with circulation: $5 to $75 per photo. B/w and some color.

Sunday Magazine: Features, picture stories, local and national. Schedule more flexible than for daily newspaper. Rates vary with circulation, $25 to $250 per photo. Also pays by day, $150 to $450. B/w and color.

Interest Self-Test

It's difficult to limit your interests; most of us are curious about almost everything. The answers you have written down should help you arrange priorities. If you absolutely hate kids, you would find it torture to pursue a lifelong career in child photography. But if you love animals, that love should be evident from the Interst Self Test and the Freelance Photographer's Handbook will help you develop markets.

• Besides photography, what hobbies, sports, or activities are you involved in? Do any photographic markets come to mind?

• What kinds of photographs do you most enjoy making?

• When you look at books and magazines, which pictures do you like best?

• If you received a grant to pursue any kind of picture-taking, what would you do?

Educational Publishing: Wide subject range: kids, nature, cultures, science, and studio setups. Schedule ranges from relaxed to panic. Requires enterprise and motivation. Pays ASMP (American Society of Magazine Photographers) rates for stock photos, $125 to $500 per photo. Day rates from $250 up. B/w and color.

Magazines: Features, news, and picture stories. Almost every type of subject matter, determined by focus of publication. Travel may be required for larger national publications. Rates vary with circulation. May pay ASMP rates for stock photos. Day rates range from $200 up. B/w and color.

Audiovisual: Educational and industrial applications. Activities, people, and products. Thinking sequentially, as a filmmaker, is helpful. Quick work and long days are the norm. Stock photo rates usually low. Day rates from $150 up. Color.

Gallery and Photo Decor: Local scenic and universally aesthetic framed photographs for decoration in private, corporate, and public space. Demanding schedule if you open your own gallery. Payment varies. B/w and color.

Television: On-air talent, news topics, issues, local views, weather. Pays $25 to $150 per photo. Also pays a negotiated day rate. Color.

Stock Agency: Sells your photos to publications, including some of those listed here. Very low pressure, but requires extreme self-motivation. Agency pays photographer 50 percent of the reproduction fee, usually based on ASMP.

National Job Picture

According to the U.S. Department of Labor Statistics, there are 105,000 professional photographers in the United States. Nearly half of them are self-employed, which is a much higher proportion than the average for all occupations. About one in five photographers works part-time. The survey in the Occupational Outlook Handbook goes on to say:

Employment of photographers is expected to grow as fast as the average for all occupations through the year 2000. Many additional job openings will occur as workers transfer to other occupations or stop working.

Demand for photographers will be stimulated by the steadily growing importance of visual images in many aspects of American life—in education, communication, entertainment, marketing, and research and development. Business firms, for example, are expected to make greater use of photographs, videocassettes, training films, and other visual aids in meetings, stockholders' reports, sales campaigns, and public relations work. Photography is vitally important in scientific and medical research, areas that are projected to experience solid growth in the years ahead. Employment in photojournalism is expected to grow slowly, with keen competition expected for available positions.

Slow growth is expected in portrait studios, about in line with the growth of the population.

Most experienced photographers and camera operators earned between $24,600 and $33,800 in 1988.

The median weekly contract wage for beginning photographers who worked for newspapers with contracts with The Newspaper Guild was about $385 in 1989. The median weekly contract for photographers with some experience (usually 4 or 5 years) was about $635 in 1989.

Photographers in the Federal Government earned an average of $25,550 in 1988.

Some self-employed and freelance photographers earn more than salaried workers. Many do not. Earnings of self-employed photographers and freelance photographers are affected by the number of hours they work, the quality of their product, their marketing ability, general business conditions, and the type and size of their community and clientele.

To start freelancing, choose your direction and take off. You'll be amazed at how work will begin coming in because you're available. If you don't take those first steps, nothing will happen.

Where are You Technically?

Many freelancers ask, "How good do my pictures have to be before I can sell them?" Unless you've just started taking pictures, you can probably start selling right now. Paying outlets exist for all photographic skill levels. The beginning freelancer who can make a reasonably good black-and-white print can work for local newspapers; the freelance advertising photographer is expected to consistently produce high-quality results. Different markets require all degrees of competency, and, of course, the pay varies accordingly.

Start. Everybody has excuses. I've heard them all. "Need more equipment." "No college degree." "Not good enough yet." Somebody out there can use you, now, while you're learning. What you must do is select the best market that your photographs can satisfy.

Look at your own pictures and critically compare them with those used by your intended market. Use the Skill Correlation Guide. If your photographs don't come close in quality, perhaps a less demanding market would be more suitable right now. If you can't compare because your pictures are of very different subject matter, practice shooting for your intended market and then compare.

Technique: Foolproof Metering

Professional photographers can hardly afford to miss a picture. Anyone can avoid improper exposure by metering the lighting conditions the way the pros do. It doesn't require expensive equipment or complicated procedures. And it guarantees an accurate exposure.

1. Set the film speed (ASA/ISO) on a hand-held light meter.

2. Hold the Kodak Neutral Test Card (gray card) at the subject location, facing the camera.

3. Take a hand meter reading from the gray card, being careful not to read beyond the gray card nor to cast a shadow on the card with your body or meter.

4. Set the camera's exposure manually according to the meter reading.

5. When the location or lighting changes, take another gray card reading.

6. If your negatives are consistently thin (or your slides too dark), use 1/2 or 3/4 of the film manufacturer's recommended ASA/ISO number.

7. If your negatives are consistently dense (or your slides too light), use 1 1/2 or 2 times the film manufacturer's recommended ASA/ISO number.

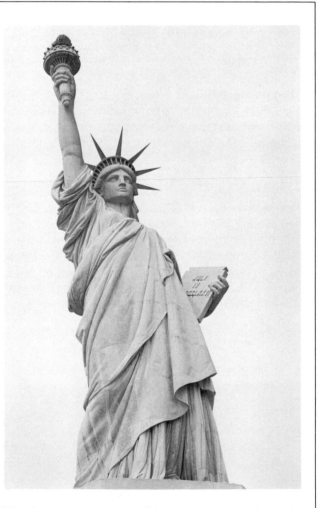

Hand metering a gray card takes the guesswork out of skyward exposures, beach scenes, and snow scenes. An overall reading of the Statue of Liberty would have resulted in a silhouette.

Photocopy this page for future use

To maximize profits, the freelancer must carefully weigh equipment expenditures. Exotic cameras and lenses should be purchased only in cases of frequent and absolute need. Consider renting—it may be cheaper. I rented an expensive panoramic camera for a few days instead of buying one. The picture sales have exceeded the rental fee, but will take a very long time to equal the purchase price.

Skill Correlation Guide

Run a technical evaluation of your target publication by checking applicable boxes in the "Media Needs" column. Compare your photographs and photo techniques by checking boxes in the "Your Skills" column. When you're done, you should have a rough idea of where you stand with any given publication. Make photocopies of this page so you can use the Skill Correlation Guide again.

Media Name _____

	Media Needs	Your Skills
1. Black-and-white photos have a solid black, clean white, and in-between, not muddy, grays. (Note: Poor newspaper reproduction may belie the original quality of a photo.)	☐	☐
2. Photos are sharp, clear, and in focus.	☐	☐
3. Color is accurate and true to life.	☐	☐
4. Composition is pleasing.	☐	☐
5. Subjects look natural, even in setups.	☐	☐
6. Special indoor lighting is used to eliminate harsh shadows.	☐	☐
7. Special equipment was used to make the photographs.	☐	☐
8. Special techniques are necessary to make the photos.	☐	☐
9. Assignments are shot in distant or hard-to-reach locations.	☐	☐

Photographic Education

There are many ways to learn photography. Most of us are self-taught in the beginning, and then get more formal training. Because there are so many fields within photography, we never stop learning. Here are the most common routes to a photographic education.

Apprenticeship: Being an assistant is an invaluable introduction to professional photography, and sometimes you get paid for it. If you can find an apprenticeship in your field of interest, take it! For example, studio photographers often hire assistants to load film, process, buy props, and "gofer." Some photographic training is helpful and often required.

Colleges and Universities: Two and four year academic programs with majors in photography are offered by these degree granting schools. Generally, these institutions require full-time students to fulfill non-photographic requirements, such as liberal arts, science, and math. I you haven't attended college, it's probably a good idea to round out your education in this way.

The *College Blue Book* (Macmillan Publishing Company) lists colleges that grant degrees in photography, along with entrance requirements, costs, and general descriptions. The *College Blue Book* is available in larger libraries. Also check out the *Index of Majors*, published by the College Entrance Examination Board, which can be purchased at bookstores. Make sure to match your interests with art photography or commercial photography programs. And if you want to take one or two courses, inquire about non-credit day and evening courses.

Workshops: These relatively new educational structures offer full-and part-time instruction. Evening and weekend programs range from basic to specialized instruction and are often intensive. Check the Yellow Pages under "Photography Schools" and the back sections of photo magazines.

Technical Schools: These differ from colleges and universities in that they do not always require non-photographic academic subjects, and grant an associate degree or certificate. If a solid photographic background is what you're after, investigate these schools. Most have evening courses. Macmillan's *College Blue Book* also publishes a volume called "Occupational Education," which lists technical schools.

Adult Education: Basic, intermediate, and darkroom courses can be found almost anywhere. Adult education is a good, inexpensive way to learn the basics of camera handling and darkroom procedures.

Adult education is a convenient and inexpensive way to learn photography. It also permits students to compare their work and recieve criticism from the instructor. This class braved subzero temperatures for a Sunday field trip.

Correspondence Schools: Home study can be an efficient method of learning photography and keeping your full-time job. It can also save you a major relocation if you don't live near a photo school. The key to learning this way is motivation. Unlike classroom learning, there's no one standing on your neck to get your lessons done. Another disadvantage is the lack of interaction with other photographers. You can solve this by joining a camera club or taking an evening course. Data on accredited correspondence schools is available from the National Home Study Council, 2000 K Street, Washington D.C. 20006.

Professional Seminars: Various equipment manufacturers and professional photo organizations conduct short, inexpensive seminars, often hopping from city to city. Their motive is to introduce a new product or service. It is worthwhile for you to get the lowdown on the latest equipment and techniques. Watch your local camera column, photo magazine, and camera store for seminar schedules.

CAUTION: Shop around for your photographic education. You wouldn't buy a camera sight unseen, would you? Take a tour of the school's facilities. Talk to instructors and students. Compare course content, reputation, facilities, and price.

Professional internships can put tear sheets into a photographer's portfolio. Endicott College (Beverly, MA) student Katherine Clark photographed students painting a theatrical set during her internship for the St. Albans Messenger. *A college education won't guarantee a job, but it can equip you with skills and, in some cases, experience.*

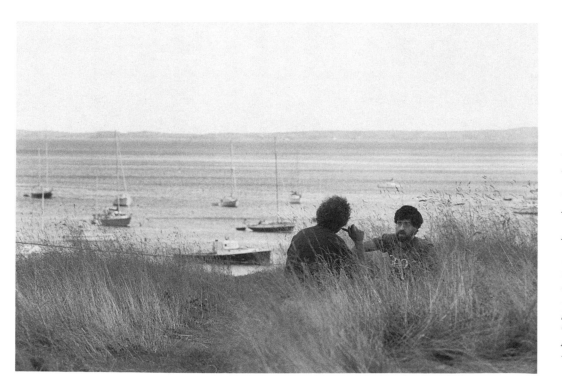

In response to demands for practical, "real world" instruction, accomplished professionals are teaching at colleges and photographic workshops. An intensive weekend course with a top shooter in your field can be enriching and inspirational to the freelancer. This one-on-one consultation took place at The Maine Photographic Workshops.

CHAPTER TWO
Starting With Local Markets

How to Get Experience

Weekly Newspapers

Yearbooks

Wedding Photography

Ideas for Local Markets

The specialty of weekly and small daily newspapers is in-depth local reporting, something the large regional papers can't do. Local events, government, people, scenes and sports comprise the bulk of weekly newspaper coverage. The experience gained while covering a protest march, a mayor, or a boy hugging his dog will pay off hundreds of rolls of film later.

How to Get Experience

Nobody starts at the top. Learning, practice, and experience are the dues paid by all photographers to reach their goals. The results of the Interest Self-Test and the Skill Correlation Guide should give you a rough idea of where you fit into the markets. For many freelancers, the local markets, such as small newspapers, organizations, and businesses are the best place to begin. The money may not be great, but you'll be photographing often and gaining invaluable experience. When the work ceases to be a challenge, it's time to move on. Every accomplished photographer has taken these steps.

Learn About Equipment

At school, we weren't taught how to reload a camera at a dead run, or which flash bracket works best when shooting a reception. There's just no substitute for actual shooting experience in learning about your equipment. If your flash doesn't always fire, find out why. Identify the best lenses for the way you work, and trade off the others. Your clients are more understanding at the local level than they are when thousands of dollars and major deadlines are riding on your achieving a successful shot—the first time! This is the opportunity to shake down your equipment, replace and add gear, perfect your darkroom techniques, and search for the perfect camera bag.

Learn About Techniques

Now you can put theory into practice. See what your equipment can do. Master the informal portrait, the desk shot, the "grip and grin." See how quickly and smoothly you can set up for a formal portrait on location. Discover what works visually, and what doesn't. Along the way, you'll invent techniques (sometimes called "winging it") and learn new ones as you need them. This is your chance to experiment, and also learn how much experimentation you can get away with. Get a feel for what a client expects, and gain assurance that you can deliver it. These first steps are not easy, but they're of prime importance to your development as a photographer.

Learn to Judge Situations

Photographic situations vary with every new place you aim your lens. No two retiring postmasters will be framed the same way, lit the same way, or posed the same way. Can you bounce flash off the ceiling? Will haze ruin the clarity of the cityscape? Where is the best location from which to photograph the pope in a crowd of two million? These questions are answered by experience. Photographic judgment increases your odds of getting good pictures. And it can only be learned one way: by doing.

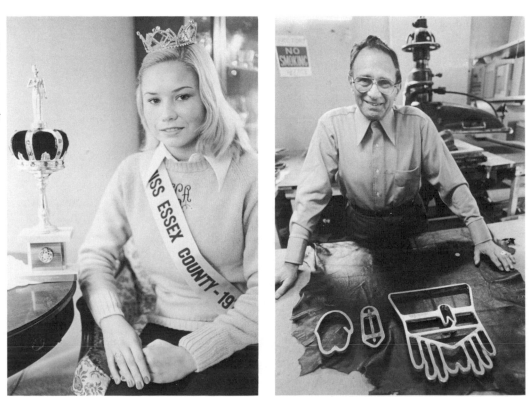

Right: Miss Essex County retired with her crown. It was an important assignment, and I improvised by using the living room table lamp. The photo ran on the front page—and I got paid $5. I learned to test my equipment before going on location, carry a backup, and always have a spare flash cord handy. The trouble taken with small assignments is the foundation of your later work.

Far right: Dealing effectively with strangers is an art that the freelancer must master. In Herkimer, NY, I had 30 minutes to meet, pose, and photograph this glover. The result was a good picture for the magazine, a pair of gloves for the photographer, and a print for the glover. A nervous photographer will find it difficult to relax subjects. Being friendly and direct will help.

Even when covering a graduation speech, you will find that questions run through your mind. Will the audience be disturbed if I walk up front? Will I distract the speaker if I start shooting at close range? (It happens.) Worst of all, will I let my client down if I don't chance these intrusions? Only experience and a photographer's sixth sense can answer such questions.

Learn About People

Photographers who move easily with presidents and celebrities once shyly photographed the local Dad's Club pancake breakfast. Confidence in your equipment and ability will give you confidence with your clients and subjects. Nervousness is caused by new situations, subjects scrutinizing your every move, too many things to remember while on location, and fear of incompetence. You'll learn to handle it while working in the relatively unpressured local markets. Another talent required of the freelancer is dealing with people diplomatically on a business level. Sooner or later, you've got to talk about money. It once took me weeks to get up the courage to ask for a 50¢ per photo pay hike from a weekly newspaper! To "read" clients and get the rates you want takes practice. Get it at the local market level.

Weekly Newspapers

The Market: Almost every community has a weekly or small daily newspaper. Cities may have several. Weeklies cover local news in detail, something the larger daily newspapers cannot do. Because they're small, weeklies usually hire freelancers instead of staffing full-time photographers. Some weekly publishers issue multiple newspapers to serve surrounding towns. You can find weekly newspapers on the newsstands and listed in the Yellow Pages under "Newspapers."

Picture Needs: Local people, events, locations, and sports comprise the bulk of weekly newspaper photos. The key word here is local. Human interest, seasonal features, and organizational news pictures are usually needed. Look for weeklies that make liberal use of photographs in picture pages and thorough sports coverage (see Chapter 6).

Breaking In: Read up on portfolios in Chapter 3. Put a dozen good pictures into your portfolio that show you can produce publishable photographs (the subjects should be typical of what appears in the newspaper). I cannot emphasize this enough: READ AND BE FAMILIAR WITH THE NEWSPAPER YOU'RE ABOUT TO SELL YOURSELF TO! Call to make an appointment with the editor. Read Chapter 4, on interviews. Good Luck!

Pay: A weekly newspaper should pay something, usually $5 to $20 per published photo. Some pay for materials and mileage. Smaller weeklies may not even have their own darkrooms, and require photographers to have their own. Always ask for payment. But if you encounter a newspaper that pays nothing, and you've never been published, do one or two assignments, and then drop it when you locate a paper that does pay. A photographer who is willing to hustle and work for several weeklies can make some money here.

Technique: Pushing Film

Pushing film is a tool that every photographer should know how to use. When the existing light is too dim to hand-hold your camera (less than 1/30 second), you can push process your film and increase it's effective ASA/ISO. Doing so will allow you to use a higher shutter speed, and shoot in low light conditions, such as circuses, concerts, and schools.

The black & white films used by most photojournalists are either Kodak Tri-X or Kodak T-MAX 400. Both have a film speed of ASA/ISO 400. Processing Tri-X in a specially formulated developer, such as Diafine, increases its speed to 1600. T-MAX 400 can be shot at 800, 1600, or 3200 when processed for the appropriate length of time in Kodak's T-MAX Developer. For extremely low light situations, try T-MAX 3200, which can be shot at ASA/ISO 3200, or pushed to 6400 and beyond.

Push processing film results in a noticeable increase in graininess, but I've never had a client complain about it. They will, however, complain about unsharp pictures. The procedure for pushing film is no more complicated than your developing method now. For detailed information, write for the free Kodak Publication J-86, Kodak T-MAX Developers: Eastman Kodak Company, Department 412-L, 343 State Street, Rochester, NY 14650-0608.

Night clubs and concert halls are often dim and prohibit the use of a flash during a performance. The only solution is to push process the film. With Tri-X rated at ASA/ISO 1600 and developed in Diafine, the exposure for this picture was 1/30 at f2.8

A parade makes local news. More often than not, the best parade pictures are of local residents watching the parade. This photo, however, was well received by the weekly newspaper because of its unusual perspective.

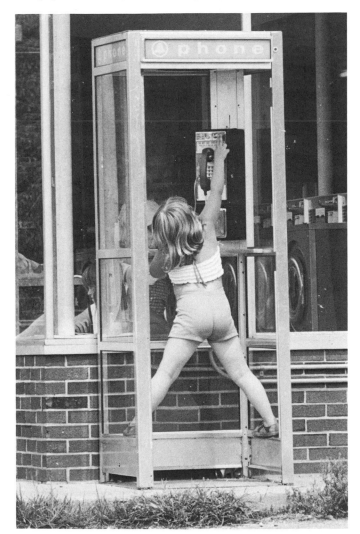

Pamela Price, shooting for the weekly Soughton (MA) Chronicle, *found this feature practically in her own backyard. Her caption: "Pam Kurinskas of Cherry St., Brockton, demonstrates how seven-year-olds use a pay phone." The photo won a New England Press Association award.*

Client's Viewpoint

Monte Temple
Managing Editor
Massapequa Post and Amityville Record
Massapequa, New York 11762

There are two types of freelance photographers: acceptable and unacceptable. Acceptable is usually a highly motivated, press-oriented photographer who knows posing and can deliver overnight sharp, clear, high-contrast glossies. Special cover assignments should show imagination.

Unacceptable is the photographer who makes a slob appearance representing my newspaper, shoots great pictures in bright sunlight and dies when he or she has to use a flash indoors, fails to show up just once for an assignment, and either screws up or fails to obtain the left-to-right identifications.

Hints on Selling: Save your artistic shadows and blurs for a Hallmark interview. Know your newspaper editor's product before you see him. Don't be afraid to shoot the first snowfall, a fire, or an auto accident, and submit it to the editor unsolicited—a great way to meet the editor. Search picture-oriented national newspapers for ideas. Be enthusiastic. Get to know the local police and firefighters, and attempt to get press credentials from them. Buy a radio monitor that scans local police/fire frequencies to alert you to spot news possibilities. After you become an aligned freelancer for a newspaper, call weekly (I prefer Mondays) to check on possible assignments.

Success Story: After calling to make an appointment, Freelancer drops by *on time* with portfolio of great shots. I lay out requirements and give him or her trial assignment. Freelancer gives great shots on time. Next assignment is Elks Lodge annual dinner. Freelancer takes my shot and proceeds to shoot each of fifty tables with twelve guests at each table. Most buy color prints at $5 each. That exposure, plus his or her weekly credit lines, leads civic groups to begin to use Freelancer to photograph their social functions for area newspapers. In addition, he or she begins covering weddings and turning out whole wedding albums. Soon Freelancer's backup help grows to a crew of four. Freelancer's part-time photo business grows even further when he or she begins accepting annual retainers as a photographer of elected officials. It all begins with one call—to me.

Yearbooks

Every high school, private school, and college has a yearbook. The U.S. Army has yearbooks for boot camp. Summer camps even have yearbooks! Unless the school has a sophisticated photo department, a freelancer takes the pictures. This is an opportunity for the beginning freelancer to shoot people in a variety of situations and start building an income.

The Market: Most of the candid, sports, and group photographs used in high school and college yearbooks are taken by freelancers. The contract given the school by the yearbook company provides for a specified number of nonportrait photographs. (A yearbook company employee or studio does the portraits.) The student editor of a school yearbook also has a budget to commission photos. Approach both the school and the yearbook company.

Picture Needs: People, mostly in black and white. Yearbooks use informal portraits, groups, all kinds of sports—indoor and outdoor—candids, and school activities.

Candids liven up a yearbook. Look for interesting activities happening near windows, so you can use the soft available light.

Right: Not all yearbook portraits need to be stiff studio shots. There is a trend toward informal outdoor portraiture, as seen here. Fortunately for the beginning freelancer, the only lighting equipment necessary is the sun and a reflector. A silvered photo umbrella or large white card can serve as your reflector.

Far right: You can set up a temporary studio at the school for more formal portraits. Keep the setup simple. Use a plain background and one diffused light.

Breaking In: First, find the schools (Yellow Pages—"Schools"). Call the public relations office at the school and ask for an appointment if there is yearbook work for freelancers. Don't overlook publicity work (Chapter 5). Get the name of the yearbook company. Call them for an appointment, too.

Pay Scale: When you work directly for the school, an hourly rate of $10 to $20 plus print fees is in order. Charge $5 to $10 per 8 x 10. Quantity portraits are priced according to the complexity of the setup and which prints are included in the price. Yearbook companies pay a modest hourly shooting fee. They give you the film and take care of all processing. If a yearbook company likes your work, they'll keep you busy at their contracted schools.

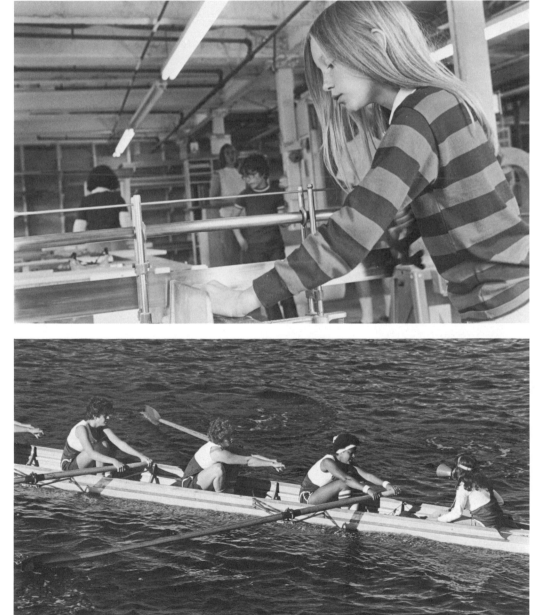

Action should be photographed inside the school as well as on the athletic field. Window light and overhead fluorescents dispense with the need for flash.

Every sport has yearbook potential. Granted, the major sports must be covered. But don't overlook intramurals, women's athletics, and lesser-known exotic sports.

Wedding Photography

Through a Studio...

Freelance photographers are inevitably asked: "Do you shoot weddings?" While a specialty apart from editorial shooting, weddings can help maintain a positive cash flow for the freelancer. And no matter how far you live from the publishing centers in major cities, people will be looking for wedding photographers.

A common way for freelancers to enter the wedding market is through established studios. Wedding studios are especially valuable vehicles for the beginning freelancer. They offer training programs, which are the best way to learn formal wedding photography. Also, a studio will book jobs for you and get you shooting on weekends. Just take the pictures and they do the rest! The beginning freelancer can earn good money and have weekdays free to pursue business clients.

To hitch up to a wedding studio, apply early in the year. That's when studios are breaking in new photographers in preparation for their busy season—spring and summer. You should have a good working knowledge of the camera and flash. Find out from the studio you want to work for if they furnish the shooting equipment, or if a 2 1/4 x 2 1/4 or 35mm camera is required to shoot their weddings. Also find out the recommended type of flash. Some studios require their photographers to carry a backup camera and flash (not a bad idea).

At first, the freelance trainee tags along with a pro, to watch. Later, you'll function as a spare—a benchwarmer who's on call to cover for any regular photographer who can't make it. Soon the smaller contract weddings will be given to the freshman photographer.

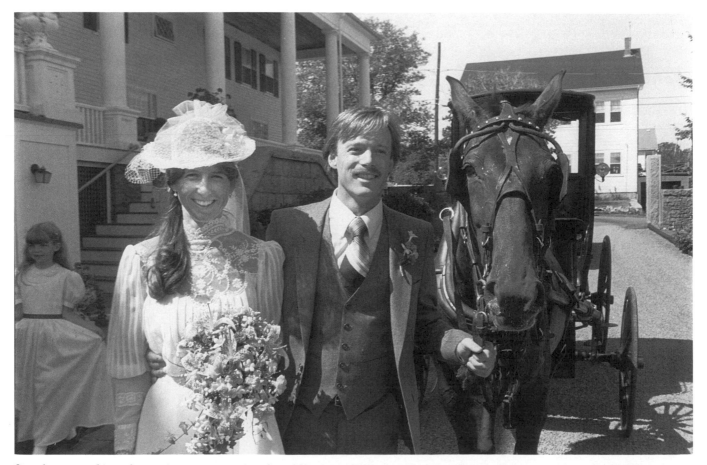

Couples are seeking alternatives to conventional weddings, receptions, and photo albums. Freelancers with a candid, documentary style can boost their cash flow by providing this service. Shooting one wedding per month, at a $900 shooting fee, can pay the mortgage.

When a studio uses you regularly, the pay will average $100 to $150 per wedding, plus travel and film. One wedding per day is about maximum, since you start at the bride's house and finish after the reception. Meals, of course, are a bonus. A good wedding photographer who is in constant demand and racks up large print orders will earn more than other photographers. If wedding photography interests you, call a local studio for an interview.

On Your Own...

Once you've garnered some experience and feel competent in the wedding arena, you may want to try shooting them on your own. Increasingly, couples are interested in relaxed, candid photographs, and are turned off by the high pressure, high volume studio photographers and packages. There's a financial opportunity here, if you can connect with these people.

Start by preparing a sample wedding album you've shot recently. It should tell the story, from beginning to end, of one couple's special day (get their permission, of course). Make use of closeups, details, and informal portraits. Stay away from gag shots and gimmicky special effects. Print up a descriptive sheet on how you shoot a wedding, what packages are offered, and how much it costs. Now you're ready to go after some business:

- Take a table at local bridal fairs.

- Place your sample album and handouts at the local camera store.

- Make contact and leave information with caterers, function halls and large restaurants, disk jockeys, and event planners.

- Put an advertisement in the Yellow Pages.

- Do a good job, and word of mouth will get you as much work as any of the above.

One way to price a wedding is the way that wedding studios do it—by the package. A wedding package is a total price, which includes the shooting fee, album, and a specified number of prints. Packages range from modest to regal, with corresponding price tags.

A basic package, for example, might offer a vinyl album cover and twenty 8 x 10 inch custom color print pages for $750. Deluxe wedding coverage could include a leather album filled with twenty 8 x 10's, ten 5 x 7's, and a dozen 4 x 5 for about $1,500. (These prices vary according to the experience of the photographer, competition, and the geographic area.)

Profits on basic wedding packages alone are marginal, since the shooting fee and cost of film, processing, and proofs are included. It's when extra album prints, parent albums, and prints for framing are ordered that the venture becomes worthwhile for the photographer. The client pays from $20 to $30 for each additional 8 x 10 print, which costs the photographer a fraction of that through a volume wedding lab. Advice from a pro: "Your customers will order more reprints if you concentrate on family members and close friends."

After the wedding, the couple looks over the proofs, which, like the negatives, remain the photographer's property. Enlargements are then ordered for the contracted album, plus any extra prints. The photographer either prepares the album or sends the order to an album manufacturer for finishing. Plan on 20 to 30 hours of labor spent on each wedding, including shooting time.

A less structured pricing strategy for weddings, especially if you don't intend to make it a major part of your business, is using a day rate. Charge a flat fee for shooting the wedding, plus the cost of film, processing, and prints. Day rates for weddings also vary with experience and market conditions, ranging from $250 to $1000, plus the cost of film, processing, and prints. The presentation of a day rate wedding can be in a formal album with an agreed number of prints, or as simple as loose prints in chronological order. One way to cut post wedding labor down to a few hours is to encourage your clients to prepare their own creative album, combining photographs, invitations, wedding cards, the caterer's bill, and the airline tickets. Whichever method of packaging and pricing a wedding you choose, be specific as to exactly what your client gets to keep—how many prints, the negatives, and if an album is included.

Traditional Wedding Poses

Bride's House
1. Bride in bedroom adding finishing touches to trousseau.
2. Bride's headpiece put on by maid of honor.
3. Bride and bridesmaids (downstairs).
4. Bride and maid of honor.
5. Bride pins flower on mother.
6. Bride pins boutonniere on father.
7. Bride alone, formal.
8. Maid of honor puts penny in shoe.
9. Bride puts on garter.
10. Outdoor photos, if nice day.

Church (enter)
11. Groom with best man.
12. Bride and father getting out of limousine.
13. Bride and father at church entrance.
14. Grandparents being seated.
15. Groom's mother being seated.
16. Groom's father being seated.
17. Bride's mother being seated.
18. Bridesmaids walking down aisle.
19. Maid of honor walking down aisle.
20. Bride and father walking down aisle.
21. Bride and father walking by (rear).
22. Father kissing bride at alter.
23. Altar from floor of aisle.
24. Altar from choir loft.

Ceremony (re-pose later if photos not allowed)
25. Bride and groom at altar.
26. Ring exchange.
27. Communion (if applicable).
28. Candle ceremony (if applicable).
29. Bride and groom kiss at altar.
30. Bride and groom face congregation from altar.

Church (exit)
31. Bride and groom silhouetted in church door.
32. Bridal party on church steps.
33. Rice throwing.
34. Bride and groom looking into door of limo.
35. Bride and groom arm in arm in limo.
36. Champagne toast in limo.
37. Bride and groom looking out back of limo.

Reception (groups)

38. Bride with her family.
39. Groom with his family.
40. Bride and groom with parents.
41. Bridal party.
42. Bride with bridesmaids.
43. Groom with ushers.
44. Groom with best man.
45. Bride with best man.
46. Bride and groom with best man and maid of honor.
47. Bride, formal poses.
48. Bride and groom, formal poses.
49. Bridal party, as introduced into hall.
50. First person to go through reception line.

Party

51. Best man toasts.
52. Bride and groom toast.
53. Parents toast.
54. Cake cutting, posed, showing rings.
55. Bride and groom feeding cake.
56. Bride and groom kiss at cake.
57. Mothers-in-law receive cake.
58. Bride and groom's first dance.
59. Parent's dance.
60. Best man and maid of honor dance.
61. Bride and her father dance.
62. Groom and his mother dance.
63. Bride and groom, special-effect photo (candlelight, sandwich, silhouette, etc.).
64. Throwing of bouquet.
65. Groom takes garter off bride.
66. Man who caught garter puts it on woman who caught bouquet.
67. Bride and groom in street clothing, with suitcases.
68. Last dance.
69. Bride and groom part from parents.
70. Bride and groom in car, rice.

Getting Married?

This may help you choose a wedding photographer...

You can have an experienced, nationally published photographer shoot your wedding. Fred Bodin has been producing magazine covers, picture stories, and wedding albums for twenty years.

It's Your Wedding: And it should be photographed the way you want—without sales pressure to buy a certain number of pictures, without stiff poses, and without the photographer running your wedding. Most people want good, honest wedding photos of themselves, their family, and friends as the wedding day unfolds. And at a reasonable price.

Style: To me, your wedding day is a story to be told with pictures. I capture the ceremonies, individual and group portraits, and the special moments that are traditional. And I look for closeup, candid photos of people relating and enjoying themselves. Details, such as a decorated mailbox, guest book, or flowers add to the unique feeling of your wedding.

Direction: I also ask the bride and groom for photographic input. If there's any photo that you'd like me to take, I'm very happy to do it. It's your wedding!

Prints: I usually shoot 6 to 8 36-exposure rolls of film at the average wedding (200-300 photographs). They are processed and a 4 x 6 inch print is made of each frame. All prints are given to the newlyweds to keep, along with a list of album suppliers and instructions.

Negatives: In addition to the prints, I also include the negatives of the wedding. Because I am usually shooting for publication, I'm not set up to sell you prints at inflated prices after the wedding. So you can make extra prints and enlargements at cost whenever you choose. Over time, you save a bundle, and you don't have to locate me ten years from now for prints.

Costs: The shooting fee for a 4 to 6 hour wedding is $900. Film, processing, and a 4 x 6 inch print of each frame is $25 per roll. The total cost, which includes all prints, negatives, and do-it-yourself album instructions, is $1,050 to $1,100 (plus sales tax in MA). The terms are 50% ($500) deposit to lock in the date, and the remainder on delivery of the wedding photos. Master Card, Visa, and American Express are accepted.

More Info: Please ask to see the sample album of Dana and Judy's wedding. Over 250 pictures were taken. If you like what you see, please call for more information or to arrange a meeting.

Fredrik D. Bodin • 5 Wiley St. • Gloucester • MA 01930 • (508) 281-3771

Now That You've Got Your Wedding Pictures...

This may help you to assemble your wedding album...

In this package you'll find negatives and prints of your wedding. Before you scatter them all over the coffee table, please take a moment to read this.

Coding: Find the first roll I shot, probably the pre-ceremony roll. Label the envelope "A" and the plastic negative sheet "A" also. Now, as you look through the prints from this roll, label each one "A" on the back (a felt tip pen works best) and stack the prints back to back until the ink dries. Do this for every roll, and you'll probably save a lot of time later locating the right negative.

Albums: You'll probably want to prepare an album for yourselves and for your family. Department stores and photo shops sell all kinds of albums. Buy the album first, then have enlargements made of your favorites to fit in it.

Enlargements: Here's where you save a bundle. Any custom color or quick lab can make enlargements. Find a lab you like and bring in the negs to be printed. You'll find that the small prints I supplied crop out a lot from the sides of the negatives. Uncle Harry's face, only half there in the print, is all there in the negative. A custom print will give more of a true full frame image (5 x 7 and 10 x 12 are exact full frame for 35mm). Print prices range from $4 to $20 per 10 x 12. Kodak is good and cheap. Master Color in Boston is expensive and the prints are exhibition quality. Generally, you get what you pay for.

Care of Negatives: With proper care, your negatives will outlive all of us. Keep out of direct sun, don't let them bake in the car, and don't ever store them in a damp basement. Keep them in the supplied acetate sheet, in envelopes, and in a safe place. You may want to set up a little drawer and filing system for all the photos you take during your adventures together.

Questions? Give me a call!

About Your Photographer: You hired a nationally published magazine photographer. My work appears in Yankee, InfoWorld, and hundreds of other publications yearly. I have also written The Freelance Photographer's Handbook (Amherst Media) and How to Get the Best Travel Photographs (Focal Press). I hope you enjoy your pictures—I enjoyed making them.

Fredrik D. Bodin • 5 Wiley St. • Gloucester • MA 01930 • (508) 281-3771

Ideas for Local Markets

Association and Community Group Functions: Fund raisers, groups, inaugurations, and retirements. Banks: Advertisements, publicity, service to the community.

Chambers of Commerce: Join, and inquiries to the chamber for photographers will be referred to you. Chambers also need quality photographs to publicize their events, and photos for press packets to publicize the area.

Construction: Progression photos are required by town, state, and federally funded construction projects. See the site foreman, company president, or architect.

Dance and Music Schools: Student recitals, performances, individual student photos, and school publicity.

Inns, Motels, and Resorts: Brochures and postcards. Free sales kit available from MWM Dexter, 107 Washington, P.O. Box 261, Aurora, MO 65605 (417) 678-2135.

Little League: Individual portraits and team photos of baseball, basketball, football, hockey, and soccer.

Political: Candidates, officials, and party functions. Local governments may need photographs for annual reports, community program brochures, and gifts for visiting dignitaries.

Portraits: Start with friends and neighbors—especially candids, children, and family portraits. Outdoor and in-home portraits can be made without a studio or studio equipment.

Real Estate: House portraits for homeowners. Various types of real estate for agencies and mortgage brokers.

Store Openings: Small stores for advertising and publicity.

Some local clients will come back every year, increasing your financial stability. In addition to the shooting fee, charge a healthy print fee ($8 to $15 for each black and white 8 x 10). Groups often order a print for everybody, making a quick assignment into a very profitable one.

Dancing schools and dramatic groups, whether amateur or professional, need pictures. It is part of the freelancer's job to seek them out and offer photographic services.

Pet photos and environmental child photography will help your profits while sharpening your shooting skills. Selling door to door demands enterprise and patience, but it can be done.

Directed Assignment

Select a local market of interest to you. Study its picture needs. Write a short, simple assignment that might be given to a photographer by this market. Now go shoot it. Compare results with pictures actually used by the local market. Unless there is a large gap in quality, set up a portfolio interview.

Example:

1. Buy a weekly newspaper that uses photos of local news, features with people, high school sports, and awards.

2. Assignment: Illustrate the coming of spring with a feature picture. Photograph kids engaged in spring time sports (fishing, baseball, with flowers, playground) within paper's circulation area. Get names, addresses, and ages of all subjects.

3. Your photos are technically good enough and interesting enough to run in this weekly.

4. Call the editor and go in with this assignment plus other appropriate photos (see Chapter 3, on portfolio).

Freelancers find work in the legal field, specifically law enforcement and insurance. When litigation looms, developers, owners, community groups, and construction firms all need photographic documentation. Leave your card with law firms, who may hire you in their client's behalf. Some freelancers shoot household inventories while the owners take notes on the valuable items. The pictures and descriptions are stored in a safe-deposit box as proof in case of future insurance claims.

CHAPTER THREE
Portfolios That Sell

Portfolio Strategy Plan

Portfolio Guidelines

A Sample Portfolio

Portfolio Strategy Plan

The freelance photographer's best resumé is the portfolio. It is the most important statement you can make to a client. Your portfolio must say two things: (1) "I am interested in this kind of work," and (2) "I am capable of doing this kind of work." Everything in your portfolio should support these two statements.

Each portfolio should be tailored or specially prepared for a specific client, who should get the impression from what you've shown that you're perfect for the job—perfect because the subject makeup of your pictures runs parallel to your client's needs, and perfect because the quality and technique of your photographs satisfy the requirements of your client. The next client you see should feel the same way, after you've made a few alterations to your portfolio.

In order to prepare the tailored portfolio, you must know your client's needs. You can accomplish this by studying the client's publication and requesting photographer's guidelines in the mail, if such information is available. Most magazines and many publishing companies supply photo guidelines. With this information, you are in a position to arrange your portfolio to suit the client.

You may wonder, "What good is all this information if I don't have the right kind of pictures?" Well, if you feel strongly about getting the job, make some portfolio photographs aimed specifically at this client. Think up a self-assignment and go shoot it. Some photographers refuse to be inventive with this kind of preparation, even though it gives a portfolio a tremendous advantage. They won't get the work—you will.

There is another advantage to targeting your portfolio to a specific client, and this has happened to me time and time again. Editors have bought photographs right out of my portfolio on the first pass. The pictures were so close to their needs that they just couldn't let them go by. When this happens, you know you've done it right.

Every single photograph in your portfolio does not need to relate directly to your client's market. Some photos appeal to many markets, and many clients look for the same things. One constant in all of my portfolios is people. Most publications need pictures of people. I also put in a shot with location lighting, one with studio lighting, and a good close-up. If you have a photo specialty, let it shine in your portfolio.

Before you start assembling your portfolio, beware of the most common pitfall: Your portfolio is not a repository for your favorite pictures. It is not a home for your landscapes, school projects, and lucky grab shots.

A portfolio is a carefully planned sales presentation. It is aimed at one client at a time. If it takes a month to prepare, then take the time. It's that important.

Preparing the Tailored Portfolio

The function of your portfolio is to get work. Your photographs may establish that you can handle the work, but in the end it's a person who gives you the job. An editor or art director looks at portfolios day after day, week after week. If he or she likes you, he or she will give you work—maybe. Part of getting the editor on your side is in your portfolio. It should be interesting as well as informative. Looking at it should be a pleasant experience.

There are no golden rules of portfolio preparation, only rules of thumb. One is to present your photos the way your client is used to seeing them in everyday work. Subconsciously, the client should see little difference between your pictures and those actually used. A newspaper editor, who uses 8 x 10 glossies, might think your large mounted prints would look better in a gallery. A gallery owner, on the other hand, would snub unmounted glossy prints. You can't please everybody with the same portfolio. Don't try.

*While this photograph finds applications in textbook and family focused publications, it is totally inappropriate to show to automotive or wildlife publication clients. Show you can do the job in your portfolio by showing photographs that actually **do** the job.*

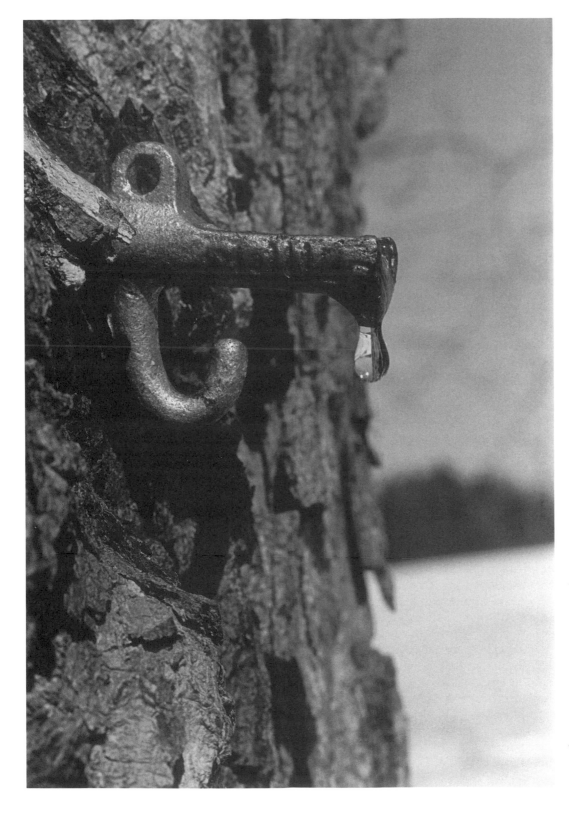

Before visiting Horticulture *magazine, I added a maple sugaring picture to my portfolio. The art director asked to hold the print for an upcoming story. Not only did I find a good client through this first interview, but the art director bought the photo and ran it in the magazine. This is tailoring a portfolio. You don't always hit the jackpot—but I would rather tailor my portfolio and put the odds in my favor.*

Portfolio Guidelines

1. Do not mat or mount prints unless the client is used to handling photographs in this manner.
2. Prints should be inserted into acetate or vinyl sleeves and put into a ring binder.
3. For publication portfolios, print size does not need to be larger than 11 x 14 or smaller than 8 x 10. I have found that 8 x 10 portfolios are well received and offer additional benefits, such as:

 a.) A client can pull an 8 x 10 portfolio print for use—it's the standard size.

 b.) The image quality in an 8 x 10 is an accurate representation of what you'll actually be submitting from assignments.

 c.) You can slip 8 x 10's into your portfolio from your files and from current assignments. Your portfolio will look fresh and is more easily tailored.

 d.) Retired portfolio prints can go into your files or to your stock agency, which accepts only 8 x 10's.

 e.) If you're lazy, like me, you'll appreciate the ease of making 8 x 10's instead of giant blowups. Your portfolio will look better, too.
4. Verticals or horizontals, not both, should be kept on facing pages. This will prevent continual rotating of the portfolio.
5. Try to achieve a thematic sequence as the pages of your portfolio are turned. Facing pages should relate. A photo of a sleeping baby next to a shot of a burning building will traumatize your clients (except fire insurance companies).
6. Show ten to twenty black-and-white prints.
7. Start with your strangest picture. End on a pleasant note.
8. Your one bad print will be remembered. Take it out.
9. You should insert 35mm slides into plastic slide sheets and put them into the portfolio book. Get the side-loading sheets—they stop the slides from falling out.
10. Edit all poor exposures, repetition, and slides with obvious color problems.
11. Bright, frame-filling subjects look best in slide sheets.
12. Show twenty to forty slides.
13. Projection of slides is not standard procedure, and is done only by prior arrangement.
14. All prints and slides should be stamped with your name and copyright notice (see Chapter 11).
15. Published work is an asset to a portfolio. Use it.

Standard 8 x 10 print:

- 8 x 10 portfolio prints have the advantage of efficient routing.

- Client has the option of pulling print for possible publication.

- Size is interchangeable with all other prints in photographer's files and photos returned from assignments. Assures closer tailoring and more frequent updating.

- Compatible with standard stock agency size requirements. Old portfolio prints can be given directly to agency.

If you were a busy editor, how would you react to a mixed
horizontal and vertical presentation like this one? Constantly
rotating a portfolio can be distracting.

A Sample Portfolio

This is a sample educational publishing portfolio. It is condensed for the *Handbook,* but is close to what I actually show to get work. The photos are in vinyl sheets, which are bound in a looseleaf book. The editor turns the pages and views the pictures in the order of the numbers at the beginning of each caption. For a detailed analysis of the textbook market, read Chapter 7.

1. Your strongest photo, or a convincing tear sheet, should start your portfolio. This one was a textbook cover.

2. Here is a photo that has proven its appeal to publishers—by selling. It is a logical choice for the market because it says "city" and "commerce" at once.

3. Another vertical city photo blends well next to #2. It has many of the most-wanted textbook elements that we talk about in Chapter 7. It also ran as a cover, but here I chose to show the print.

4. Textbook illustrations are aimed at the age group for which the book is written. It is a must to include constructive teen activities in a portfolio for the high school market.

5. My Hispanic couple has many textbook applications: relationships, psychology, family life, and sociology.

6. Include some horizontal photographs, and put them on facing pages. The woman geologist is a useful illustration for career chapters in science books. Women executives, professionals, and scientists should be evident in your portfolio.

7. Business texts jump at the chance to include a woman realtor and a young couple with a baby buying their first house. The portfolio only needs to be rotated 90 degrees to view both horizontals.

A Sample Portfolio, continued

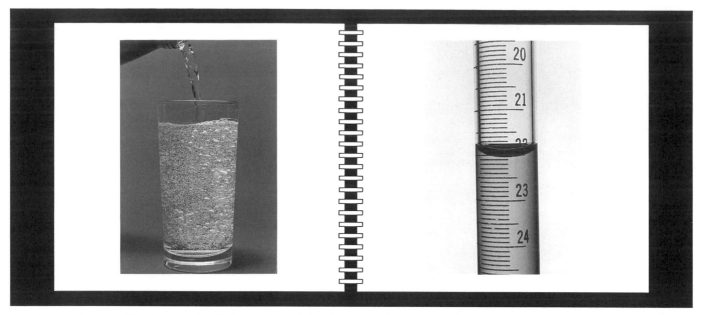

8. One or two studio photos should be included for the textbook market, to show that you can do it. This is a picture of carbonation, which must be shot with flash if you want to freeze the bubbles.

9. How to read a meniscus. The photo tells an editor that the photographer can do studio work and close-ups.

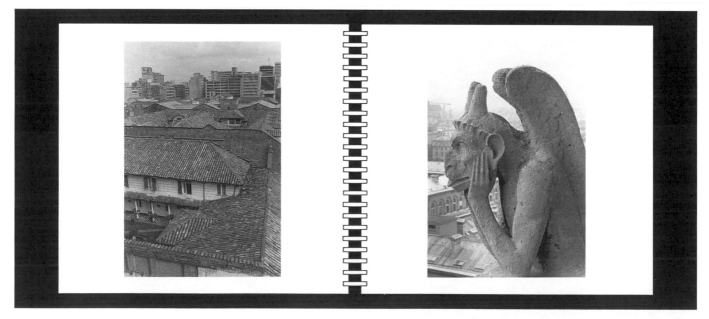

10. Spanish is a popular language to study in school. The old and new cities contrast in this photo of Bogotá, Colombia.

11. Foreign scenes are candidates to illustrate U.S. language textbooks. While a publisher may not send you abroad on assignment, it may purchase photos you have already taken in Europe or elsewhere. Selling stock photographs can be a lucrative business (see Chapter 10).

12. Father and child show how sex roles are changing in today's marriages. I like to end my portfolios on a pleasant note.

13. Your portfolio slide sheet(s) should be easily removable for light-table viewing. If you have 2 1/4 x 2 1/4, 4 x 5, or larger transparencies, they can be matted or inserted into vinyl pages.

Portfolio Checklist

☐ Identify client.

☐ Obtain sample publication and photographic guidelines.

☐ Research picture needs of client.

☐ Tailor portfolio to client's picture needs.

☐ Shoot, if necessary, to slant portfolio to client's needs.

☐ Prepare questions and ideas (see Chapters 4 and 8).

☐ Interview (see Chapter 4).

CHAPTER FOUR
The Photographer's Interview

Interview Preparation

The Photographer's Resumé

Narrative Resumé

Interview Tactics

Interview's are as much a part of getting work as your portfolio and taking a good picture. Solid preparation on your part allows the true function of an interview—fact-finding—to take place. After you've done your homework, you can be proud of what you're showing and enjoy the excitement of the moment.

Interview Preparation

When I started freelancing, I hated interviews. I would lose sleep, pace, smoke five cups of coffee, drink ten cigarettes, and get words mixed up. I was so bad that I made the client nervous. I prayed that one day I'd get lucky and run into some work. I didn't know what I was doing wrong.

My problem? Like many photographers, I was not prepared to sell my work to a potential client. I didn't know the client's product, my portfolio was not tailored, and sometimes I wasn't even sure I wanted the job. The deck was stacked against me before the appointment was ever made.

Now interviews are fun. When you're prepared, the experience takes place on an objective and professional level. You don't always make a sale—nobody does that. But at least you are more likely to know why you missed it and what can be done about it.

It Pays to Be Liked

All freelance photographers can't go to finishing school, but being liked is a definite advantage. Ask any salesperson or any accomplished freelancer. Given the same quality of work, a freelancer who is liked will be hired. Your client must feel that you're dependable, easy to work with, and will continue to deliver quality work. That's your client's job. Thus, if you build a working relationship, you will probably achieve a loyalty that will transcend the price of the photographs.

Let your personality shine at the first interview. It may be your last chance. Be attentive, be positive, be friendly. Most of all, be interested in your client's work. Display your research. Show your knowledge of the publication. Be enthusiastic about learning more.

Don't brag. Don't berate other photographers, other publications. A cynical photographer is boring. Accept criticism gracefully. If it's valid, you've learned something. If it's off base, forget it. Be firm about what you want, but don't be pushy. In short, be normal. Do not crawl, but don't come on like a celebrity. You're a professional selling pictures to get the job done.

This isn't a charm course, but the bottom line reads: "Be liked and get more work." So be liked. I've read some interesting books on this subject. They're worth checking out:

Dress for Success, by John T. Molloy (New York: Warner Books, 1984).

How to Win Friends and Influence People, by Dale and Dorothy Carnegie (New York: Pocket Books, 1981).

The key to successful interviews is preparation. It starts here, at your light table, where you select the kinds of photographs your client wants to see.

Telephone Tips

Your first contact with a potential client is by telephone. Here are some hints to help get your foot in the door:

- Introduce Yourself: Right off the bat, tell the editor who you are and what you do. "Hello, my name is Fred Bodin, I'm a photographer in the Boston area, and I'd like to arrange to show you my portfolio."

- Overcome Objections (such as low budget or regularly used freelancer): Without being pushy, show that you're willing to negotiate fees or wait for an opening to get some work. "Quality photography might not cost as much as you think;" or "I'll be happy to show you my portfolio, just in case you ever need an additional photographer."

- Gather Information: Find out if there's an upcoming theme or story that you might work into your tailored portfolio.

Pre-Interview Checklist

- [] Be familiar with client's product or publication. Read current issue.

- [] Research and analyze client's photo needs. Consult photographer's marketing books. Write client for photographer's guidelines.

- [] Prepare business card and resumé (if necessary).

- [] Tailor portfolio to client.

- [] Write down questions.

- [] Outline creative ideas for client's publication (see Chapter 8).

- [] Call for an appointment. At this time, also ask if there are any specific photos you might bring when you come. You might have just what they're looking for in your files!

The photographer's interview starts before the appointment is made. An understanding of the potential client's needs and preparing your presentation accordingly must necessarily preface any interview. A freelancer who is prepared for an interview will get the work.

The Photographer's Resumé

The freelance photographer's resumé is a portfolio, most of the time. But like it or not, there are some times when you'll need a typewritten resumé in addition to your portfolio. Teaching jobs require resumés. So do consulting and part-time jobs. Occasionally a publication may request that a resumé precede the interview.

Standard Resumés

The standard resumé is a formal and factual list. Business-letter writing manuals offer several variations, all of which must be adapted to freelance photography. Do not list non-photographic jobs unless they relate to the position you're after. Tailor your resumé, just like your portfolio, to a specific client. List photographic skills, formats, and clients.

A freelance photographer's work record doesn't always fit into the slots designed by the corporate world, so this resumé must necessarily depart from the norm. On the next page is a sample. Each section is numbered, and the explanation of it appears below. The objective of this standard resumé is to secure a part-time photography job at a large corporation. In this case, a resumé was requested at the interview.

Ulrike Welsch, courtesy of Boston Globe

The purpose of a standard resumé, according to an employer, is to allow the employer to check you out from his or her desk. You want the resumé to get you in the door for an interview, show your pictures, and check out the employer.

1. NAME, address, and phone number. If you have a printed letterhead, omit.

2. Neat, friendly PHOTOGRAPH of applicant pasted onto resumé. Optional.

3. EXPERIENCE. Open listing with the job that will impress client most. List others in order of decreasing importance. List all experiences, nine-to-five or assignments, which show you've got the qualifications the employer is looking for.

4. SKILLS may elaborate on your experience and should be listed in order of importance to employer. Ideally, you have all the skills the client is looking for. Some second-guessing is required on your part.

5. EDUCATION. Note degrees, major, college, and year of graduation. Also list special training (workshops, seminars, etc.) if relevant to position sought.

6. EMPLOYMENT OBJECTIVE should coincide or seem consistent with the job you're applying for.

7. REFERENCES may be listed, especially if the employer's decision is imminent.

8. Note: Personal information, such as marital status, age, health, hobbies, or membership in organizations is not expected or required on a resumé. Offer this information only if it clearly benefits you. For example, if the job you're after requires extensive travel, stating that you're single might reinforce your suitability for the position.

1. **Fredrik D. Bodin • 5 Wiley Street • Gloucester • MA 01930 • (508) 281-3771**

2.

Resumé

3. **EXPERIENCE:**

U. S. Trust: corporate banking public relations photography; 1986 to present.

H.P. Hood Dairy: corporate public relations and product photography on location; black and white and color. Formal executive portraiture, marketing teams, new products for in-house publications and national magazines. 1985 to present.

Mullen Advertising: corporate public relations photography for law firms, computer companies, and food industry, such as Smartfood. 1985 to present.

InfoWorld Magazine: Location photography of hardware and software industry leaders, and innovative applications. Topics include: Mitch Kapor of Lotus Development, Spinnaker Software, venture capitalists, and MIT's CD ROM-based Project Athena. 1983 to present.

4. **SKILLS:**
Executive, formal, and informal portraits.
Location and studio lighting of people and products.
Public relations photography for corporate and industry publications.
Black and white press release photographs produced quickly.
Camera formats from 35mm, 2 1/4 x 2 1/4, 4x5, and 8x10.

5. **EDUCATION:**
B.S. Photojournalism, Syracuse University, S.I. Newhouse School of Public Communications, 1972.

6. **EMPLOYMENT OBJECTIVE:**
Corporate and industrial photography.

7. **REFERENCES** and **PORTFOLIO** are available on request.

Narrative Resumé

Narrative resumés are preferable when you know you'll be competing with many others for an interview. Let's say that you're responding to a newspaper advertisement: "Large corporation seeks versatile photographer for small product photos, some people, some travel. send resumé Box 191." A lively narrative resumé would probably get you inside among the many standard replies. Getting over that first hurdle is the purpose of the narrative resumé.

Tailor the narrative resumé to fit the job. Start with a dramatic achievement in the lead sentence. It should impress the client and demand further attention. Put yourself behind the client's desk, then relate all the skills that he or she wants and that you (the photographer) have. You should appear to be perfect for the job. Avoid giving the impression that this job is a stepping-stone. Let the client think, from your resumé, that you were born for this job. Read Carl Boll's *Executive Jobs Unlimited: Updated Edition* (New York: Macmillan, 1980) to perfect your narrative resumé.

A freelance photographer's resumé fits better into the narrative than into the standard format. If I were applying by mail for a position and I suspected that the first round of competition would be fought by resumés, I would send a narrative resumé. Its immediate objective is to get you an interview.

The resumé on the next page is aimed at the ad: "Large corporation seeks versatile photographer for small product photos, some people, some travel. Send resumé Box 191." The resumé components are described below.

1. NAME, address, and phone number. If you have a printed letterhead, omit.

2. Hook the reader's attention with your most impressive ACHIEVEMENT. Present it in an interesting way, so the reader feels curious enough to go on. The achievement you choose to start your resumé with should relate to the job you're after.

3. Give details of EXPERIENCE. Mention only experiences that will concern the reader. Second-guess what they're after.

4. Freelancers must LIST CLIENTS instead of full time employers. List the clients that will impress the reader most.

5. If you're in the running for the job, the client will ask for REFERENCES and portfolio.

Narrative resumés make you stand out in a crowd of applicants with standard resumés. Pique an employer's interest to snare an interview. Only then do you have a shot at the job.

1. **Fredrik D. Bodin**
 5 Wiley Street
 Gloucester, MA 01930
 (508) 281-3771

Resumé

2. Covering seventeen states in six weeks, I photographed camera equipment for a book publisher, destinations for two national travel magazines, and a poster and trade advertisement for American Optical. Over the past five years, I have concentrated on people and the tools they use in the corporate world.

3. Assignments have focused on personalities such as: Mitch Kapor of Lotus Development, Bill Bowman of Spinnaker Software, MIT's Project Athena team, and Hood Dairy's CEO with the new product line. My photographs have been used for in-house newsletters, catalogs, press releases, trade magazines, and national consumer publications.

4. Clients include U.S. Trust, H.P. Hood, InfoWorld Magazine, LIFE, National Geographic Books, Mullen Advertising, Smartfood, Harvard University, and the Boston Children's Museum. My photographs are represented in the United States by Stock, Boston, Inc.

5. Both studio and location shooting are supported, in black and white and color, in formats from 35mm to 8 x 10.

6. References and portfolio are available on request.

Interview Tactics

1. Dress as you expect your client to dress. You want to fit in rather than be looked down upon or inspire awe by your appearance.

2. Don't wind up with coffee, cigarettes, or booze before an interview. Jitters will make your client nervous. Give yourself plenty of time to arrive and calm down.

3. Be on time.

4. Relax with the interviewer with some non-business conversation when you first meet. However, if he or she wants to get right down to business, let the client guide the interview.

5. Let the client set the pace for looking at your portfolio. A comment on each photograph is not necessary.

6. Ask intelligent questions about the client's product or publication. Show you've done your research and add to it.

7. Take notes.

8. Suggest carefully thought-out ideas of interest to you and the client (see Chapter 8).

9. If rates are unknown or seem low, talk money.

10. Create the space for future transaction: offer to bring in a needed stock photo; develop a suitable idea for the client; after an agreed-upon time period, bring in new work.

11. Do not linger. Look for signals that indicate the end of the interview.

Post-Interview

- Respond immediately to leads, picture requests, and idea development.

- Evaluate market potential of client. Fill out a Photo Market Analysis (next page) and keep it on file.

- After a reasonable amount of time, re-contact the client with something new.

- Investigate parallel markets.

A good interview is friendly on the personal level and serious on the business level. It is a meeting of two professionals—exchanging information and ideas, and hopefully getting down to work.

Photocopy this page for future use.

Photo Market Analysis

Client: _____ Phone: _____

Address: _____ Fax: _____

Type of Media: _____ Contact: _____

[] Market Resource Book [] Sample Copy [] Photo Guidelines

Content: _____

Number of Photographs: [] Few [] Moderate [] Extensive

Uses of Photographs: [] Single [] Photo Story/Essay [] Page

Quality Standards [] Low [] Moderate [] High

Reproduction: [] Black and White [] Color [] Both

Picture Needs: _____

Approach: [] Stock Sales [] Speculation [] Assignment [] Ideas

Interview/Submission Results: _____ Date: _____

Rates Quoted: _____ per day, _____ per page.

Re-contact Date: _____

Material/Photos Requested: _____

Future Ideas: _____

CHAPTER FIVE
Publicity and Promotional Photography

The Market

Picture Needs

Breaking In

In the Field

The publicity and promotional photo market is all around us—wherever business is transacted. Educational institutions recruit students with catalogs, press releases, and slide shows. Publicly funded organizations document their achievements for renewed funding. And corporations recognize the value of favorable public opinion, and are willing to spend money to sway it.

The Market

Publicity and promotional photography lies between advertising and journalism. It is the documentation of an establishment's production or activities for community relations, fund raising, image building, internal communications, public information, and recruitment. This field differs from advertising in that advertising space is not bought to sell a product or service. It differs from journalism in that the subject material is of interest only to the employees, customers, and potential customers.

Businesses of any size recognize the value of good public relations and promotion. For the huge education and health-care industries, publicity and promotion are essential. Highly trained professionals run these corporate departments and are responsible for producing press releases, magazines, newsletters, catalogs, and brochures. They hire writers, designers, and photographers. You'll find publicity people who take their own pictures, but they'll also hire freelancers to guarantee quality and to meet the pressures of deadline. You'll even find corporations with staff photographers. Don't be put off; some of my best clients have access to free staff photographers. But staff photographers are often too busy and/or take uninspired pictures.

The demand for quality publicity and promotional photographers has created a large market for freelancers. I have found this work to be constant, and it pays as well as magazine work. The number of potential clients is staggering. The geographic distribution is wide—you can find publicity and promotional work behind any established business. The following chart will give you an idea of the diversity of clients and their output in this field.

Large universities hire freelancers to shoot publicity and promotional photos, even though staff photographers are on the payroll. If you can turn ordinary assignments into extraordinary pictures, in-house staffers will pose no problem.

Publicity and Promotional Photo Chart

Client	Brochure	Calendar	Catalog	Fund Raising	Magazine	News-letter	Press Release	Slide Show	Subjects
Animal Rescue Society	•	•		•	•	•	•	•	Veterinarians, rescue, wild and domestic animals
Business, General	•	•	•	•	•	•	•	•	Personnel, product, facilities, functions
Chambers of Commerce	•	•			•	•	•	•	Business opportunities, festivals, landmarks
Colleges and Universities	•		•	•	•	•	•	•	Students, teachers, events, facilities
Community Service Programs	•			•		•		•	People and community, work and progress
Developers	•		•		•	•	•	•	Facilities, people, services
Environmental Organizations	•	•		•	•	•	•	•	Pollution and clean-up, nature
Governments	•				•	•	•	•	Awards, people, buildings, programs
Historic Restorations	•	•	•	•		•	•		Events, people, restoration
Hospitals	•				•	•	•	•	Health care, staff, patients
Museums	•	•	•	•		•	•	•	Artwork, exhibits, galleries, people
Orchestras, Theater	•			•			•	•	Performers, concerts, tours
Police	•				•	•	•	•	Technology and community interaction
Professional Organizations	•			•	•	•	•	•	Awards, banquets, achievement
Resorts	•	•					•	•	Activities, facilities, locale, tourists
Transportation	•	•			•	•		•	Modes of transportation, personnel, destinations
Zoos	•			•	•	•	•	•	Animals, people, personnel

Picture Needs

The publicity and promotional client wants pictures of people, and most such photos are shot indoors. I find the people photos falling into three categories: (1) head shots, (2) desk shots, and (3) occupational activities. You should master these and represent them well in your portfolio.

Most publicity work, especially for the entering freelancer, is done in black and white. You will be asked to take pictures in a variety of lighting and special situations. Use available light when you can, but assume the worst and always bring a flash. You'll find that whereas local markets are content with direct flash or harsh available light, the publicity and promotional market is not. Here is where many freelancers fall short. You must be able to throw a natural-looking light on your subject. Learn it now, because flash lighting is a link in the chain. You'll need it for magazines, advertising, annual reports, and most other lucrative markets. Pay attention to "Technique" and "Self-Assignment" in this chapter.

A recurring picture need (and nightmare) in publicity and promotion is to make an interesting picture out of a dull situation. Some situations are so boring that you need to be a magician, but it's part of the job. Be lively and animated in your approach. Your own enthusiasm and some of the following hints will give these pictures a transfusion.

Think it Through: If the concept behind a photograph is weak, the result may be unsatisfactory for both you and your client. Know exactly what your photograph's mar-keting mission is. Don't be afraid to suggest alternatives. Constructive input from a thinking photographer makes you a more valuable player on your client's team.

Direct: Many "interaction" photos must be staged. You must direct. First, explain to your subjects what you're trying to achieve. With camera angles in mind, arrange the subjects in a natural and photogenic way. Be careful not to space them too far apart. Now, action!

Staging a discussion is difficult. Suggest a topic. Start the conversation. Ask for gesticulation and animation. If an occupational activity is called for, have your actors accurately perform it until you get the photo.

Timing: With activities and interaction, timing the photograph is important. It can separate your pictures from the standard shots. Follow the expressions and emotions of your subjects. Stalk dramatic moments. Look for symbols, subtleties, and humor. Shoot until you know you have the right shot.

Go Beyond: Once you've covered the assignment in the suggested way, go beyond it. Try closeups, different backgrounds, and unusual viewpoints. Very often, clients are delighted by unusual techniques that make the photo more interesting. Just don't forget to cover the basics first.

It's easy to overlook the fact that your publicity and promotional clients buy stock photographs. Look over their publications and make them aware of the stock coverage in your files. There's no reason why an assignment photographer can't also be a stock supplier too. Examples of stock photo usages in this field are cityscapes, individual and family portraits, and mood pictures (see Chapter 10).

Left: Portraits, or head shots, are a mainstay of publicity work. This head was shot with ceiling bounce flash and an 85mm lens. Right: Much office activity takes place behind a desk, hence the desk shot. You may need to do extra shooting to get an interesting pose and composition. Don't forget to remove desk clutter. This lawyer was photographed under available light with a 35mm lens.

Occupational activity photos frequently show the interface between worker and the machine. A wide-angle lens is indispensable, as is portable lighting. The seismologist was lit with a soft box. A 24mm lens was used.

Technique: Flash

Buy the most powerful electronic flash you can afford. A weak flash is limiting. Look for rechargeable batteries (to save money), thyristor circuitry (for more flashes per charge and faster recycling), an automatic exposure eye which functions during a bounce flash procedure, and an exposure verification light which tells you there is enough light to make a picture. Use Kodak Tri-X or T-Max 400 film.

When you enter a room, evaluate the available light. If it is unflattering or too dim, even with push processing (see "Technique," Chapter 2), look up. If the ceiling is light and low enough for bounce flash, use it. When you are shooting in color, the ceiling must be white.

No ceiling? Here are my contingency plans, in order of preference: Set up a portable soft box or umbrella. Bounce light off a large hanging light fixture. Suspend a white flat from the rafters. Bounce off the wall. Rig your flash with a bounce card or diffusion device. My last resort is direct flash.

Bounce flash is best done if you hold the flash at arm's length above the camera. This extends your bounce power and enables you to use higher ceilings. All the stretching requires the sturdiest flash cord that money can buy. When your flash does not fire, check the cord and connections. This is the usual culprit of flash malfunctions. I always carry a spare.

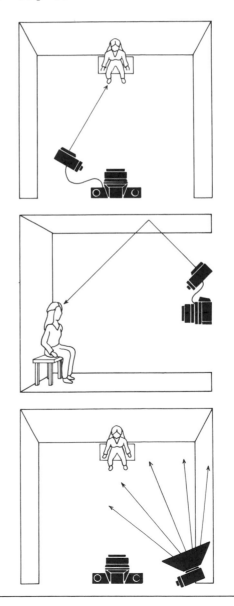

Breaking In

When your flash techniques are consistent and your available light photography is sharp, prepare a publicity and promotional portfolio. Be certain to include a head shot, a desk shot, and an occupational activity. Include some well-executed flash pictures.

Call the company you are interested in working for and ask for the public relations office. The same office may also be titled public affairs, public information, publications, media, or graphics. Failing all else, ask for the person who sees photographers. Because company publications are usually not for public consumption, you must inquire on the phone about what kinds of publications are produced and what kinds of photographs are used. Make an appointment to show your portfolio. Ask if the client would like to see color or any specific pictures. At the first interview, you can get sample publications.

Prices and Terms

Prices vary wildly in this field. Publicity and promotional clients will pay beginning freelancers low rates for routine shots, and then pay an experienced freelancer a good rate for a more complex assignment. There seems to be room for all skill levels in this market. Beginning rates might be $10 per print and no hourly fee. To the freelancer, this means no money if you don't produce. To the client, however, this is an inexpensive way of auditioning new talent. Bend with it once or twice. I suggest a starting rate of $20 per hour and $10 per print.

Experience and expertise will command larger fees. Clients who originally hired me for $25 per hour now pay $125. We both felt rate increases were justified. Occasionally, a publicity client will need you for an entire day's shooting. Offer a slight discount from your hourly fee.

Frequently, publicity clients will want you for only an hour. At some point it will dawn on you that it takes the same preparation and driving time to shoot for one hour as it does for four. And if there's other work waiting, you're losing money on the one-hour jobs. I charge my clients a minimum of $125 for the first hour, and they are encouraged to buy the second hour for $100.

Expenses such as parking, color film and processing, and lengthy travel should be billed to the client. Included in my hourly fee is the cost of black-and-white film and contact sheets. I allow my client to file the contact sheets for future print orders.

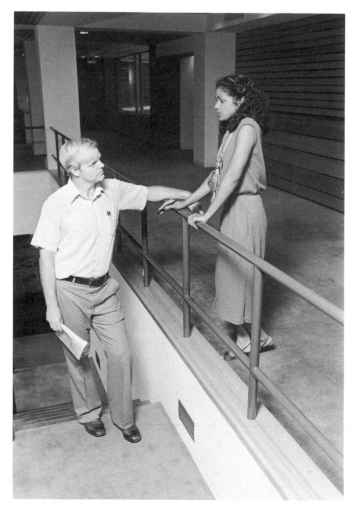

Staged conversations are difficult to set up. Pretend you're a movie director and make your subjects act. A photographer who can stage photos to look natural will be valued by publicity clients. Do you think this photo works?

Make very clear to your clients what rights they are buying. For the publicity and promotional market, I specify on my invoice that "Publicity and promotional rights are granted to the photograph(s) listed above. Client may retain contact sheets and prints." Thus I allow the public relations department to build a file of useful photographs and use them only for public relations. When a stock photo is sold to this client, however, it is on a one-time basis and must be returned.

Never surrender negatives to a client. If you turn them over, say goodbye to future print fees, all control over client use of the pictures, and future stock sales. When a client asks for the negatives, make your case: "I'm storing the negatives in a safe and secure environment, catalogued for easy retrieval"; "I do this for your

convenience. Order prints from me at any time"; and, as a last stand, "Resale of photographs is part of my income. Giving you the negatives would entail a much higher fee."

I don't even lend clients my negatives. They may never be returned, or will probably come back damaged. Negatives don't travel well. And if your clients think they have legal rights to the ownership of your photos, have them read Chapter 11 of the Freelance Photographer's Handbook.

Color transparencies present similar problems. Don't give them up. The solution is to consign the transparency (see Chapter 10) to your client, making it clear verbally and in writing on the consignment that "all original color transparencies are property of the photographer and must be returned. Photographer will arrange to have duplicates made for client use." Your client can now file duplicates of the most useful slides for reference, slide shows, and other promotion. For quality color reproduction, your client can always recall the originals.

"After the alumni dinner." Sometimes it's worthwhile to wait for a special picture. This photo has more meaning than one of sixty alumni wolfing down their meals.

Creative experimentation is appreciated by clients, but first cover the basics. After the dancers were photographed with a fast shutter speed and conventional sharpness, I used a slow shutter speed to accent their movement.

In the Field

Directed Assignment: **Publicity and Promotion**

Find three locations and models for photo sessions.

1. (a) Office with enough light to shoot Kodak Tri-X or T-Max at ASA/ISO 400 or pushed to ASA/ISO 1600. Make eighteen exposures of professional-looking person sitting at desk. Vary camera angles, lenses, and poses for every shot. (b) In same office with same model, take eighteen head shots. Use three different locations within office.

2. Office with white ceiling low enough to bounce flash Kodak Tri-X or T-Max rated at ASA/ISO 400. Repeat (a) and (b) above, using bounce flash.

3. In business or industrial setting, use bounce flash to photograph someone doing his or her job. Pick an interesting situation. Highlight the machine. Show how the person relates to the environment. Shoot thirty-six pictures.

4. Print five best photographs. This is the beginning of your publicity and promotional portfolio.

Above: An alternative to the dull awards ceremony. If sports photographers can catch the peak of action, so can the publicity and promotional photographer.

Right: Groups require a wide-angle lens, masterful direction, and plenty of patience.

Client's Viewpoint

Peter Minasian
Director of Marketing Services and
Corporate Communications
H.P. Hood, Incorporated
Boston, MA

By way of background, H.P. Hood is the northeast's leading producer of dairy, citrus, and cheese products, being in business for close to 150 years.

I expect a freelance photographer to be familiar with our product and heritage, in the same way an applicant for a full-time job studies the history of a prospective employer prior to an interview.

Our photo needs usually fall into two categories: food/packaging for advertising and publicity, and corporate management portraits. The food/packaging photography requires a sophisticated studio with the usual complement of strobes, backgrounds, kitchen, and access to professional stylists. I value a photographer who can use lighting effects to achieve a desired effect and to best target the consumers we want to reach.

Corporate portrait photography emphasizes personal skills. The freelancer should find out who the subject is, why they're being photographed, and what purpose (newspaper or magazine) the picture will serve. The photographer must also be flexible to accommodate the workday needs of the corporate executive.

In addition, the photographic background should complement the executive being photographed and the company. Be prepared to suggest the proper combination of suit (medium color, solid), shirt color (off-white), and tie (stripe/club) or necklace (simple, clean). Since most subjects are self-conscious in front of the camera, you may need to relax them and direct their facial expressions to gain the desired look.

Before you leave the shooting location, determine the deadlines for contact sheets and prints, and/or slides. Be prepared to mail material directly to a publication to meet a tight deadline.

It is essential for the freelance photographer to create the perception that he or she always brings added value to each assignment. Establish a "point of difference" in your style that will set you apart from the competition. And it all begins with high quality promotional materials showcasing your capabilities, proper attire, and your correct interpretation of the needs of the assignment.

The basic kit for executive portraiture can be carried by one photographer and consists of: 1) 35mm or medium format camera with portrait lens; 2) main light, strobe or tungsten, on stand with diffusion; 3) seamless background paper of the appropriate size and color; and 4) a set of stands designed to support background paper on location. When using tungsten lights, a tripod will probably be necessary, and a Polaroid test is reassuring when shooting with strobes. At the very least, a modeling light on the strobe is needed to position the light correctly. Buy two lightweight stands with an adjustable crosspiece to hang the seamless paper from. Head shots can be done on 4 1/2 foot wide seamless paper. Using tape to hang the background paper is risky—the paint or wallpaper may come off with it!

Set up in a conference room or empty office. Make sure you have enough time to be completely ready when the executive(s) walk in. Shooting a test on a person sitting on the model's chair or stool will detect problems with shadows, exposure, or background. It will also put you and your client (who is usually looking over your shoulder) at ease. Once the executive is seated, don't be afraid to straighten the tie and jacket, snip a loose thread, or smooth a strand of hair. Shoot a range of expressions ranging from a serious look to a slight smile to a wide grin. And if your subject appears to be blinking, shoot extra.

CHAPTER SIX
Daily Newspaper Photography

The Market

Picture Needs

Breaking In

In the Field

News photography is exciting. You're always in the public eye. News photographers have special access to the great, the tragic, and can transform the pedestrian into the idyllic. This is why jobs in photojournalism are most sought after by photographers, despite a disproportionate number of employment opportunities.

The Market

The daily newspaper uses large numbers of pictures every day of the year. When we hear the word "newspaper," we tend to think only of big news events and major league sports. Photographically, a newspaper is much more: community news, consumer reports, entertainment, home and garden, in-depth photo essays, and travel.

Almost all daily newspapers have staff photographers. But even with staffers, a daily can't cover all the news or find all the features, and nobody has a monopoly on good story ideas. Freelancers interested in selling to newspapers have a market in every city and large town, and in many suburban areas.

The role of the freelance photographer at a daily newspaper is a varied one. A freelancer can supply a one-time news photo, come in periodically with news or features, or be a "stringer." Shooting as a stringer, or a regularly used freelancer, is an apprenticeship of sorts. The stringer gains experience, skills, contacts, and may eventually land a full-time job on a paper. Stringers located near the newspaper supplement staff photographers, and remote stringers in surrounding towns and states can reach news events in their area quickly and eliminate travel time for staffers.

The intensity of daily newspaper shooting is a proving ground for photographers. Experience and published work are gleaned quickly—making newspaper a solid steppingstone to other fields. In fact, the majority of editorial and magazine shooters cut their teeth shooting news. Apart from the experiential advantages of the newspaper, there are also specialized and better paying departments, such as travel and the Sunday magazine, which accomplished freelancers court.

Large daily newspapers can be found on the news stands. Smaller dailies, especially in the suburbs, are much less visible. Check the Yellow Pages under "Newspapers" to find papers within driving distance. Newspapers beyond your immediate territory, but still within your geographic region, are also potential markets. In the Midwest, freelance photographers in Chicago can sell photos about the city to newspapers in surrounding states. Conversely, Chicago papers buy images from photographers in outlying areas. A freelancer should use his or her base location to advantage in selling work to out-of-town newspapers.

Shooting for a news or wire service is similar to freelancing for a newspaper. These services supply newspapers across the country and around the world with news stories and photographs. Two well-known wire services are Associated Press (AP) and United Press International (UPI). Photographs are transmitted electronically, via telephone or satellite, to subscribing newspapers. News services also gather and distribute information, and some specialize in business, entertainment, or regional news.

The wire services maintain branch offices in major cities. In addition to staff photographers working out of the office, freelancers are used extensively. At important events, freelancers and staffers openly compete for the best news photo. When news happens far from the wire service office, a stringer might be called for coverage. News and wire services are listed under "News Service" in the Yellow Pages.

Pam Price

Whatever the President of the United States does is news. Credentialed staffers and freelancers alike cover "photo ops," which are carefully arranged shooting sessions. Pam Price, who photographs at the White House frequently, enjoys the excitement of being in proximity with the President and world leaders.

Wherever there is controversy and conflict, there is news. Demonstrations are always open opportunities for the freelancer. Sometimes just keeping yourself out of the fracas is an art in itself. Michael Grecco's anti-nuclear demonstration photo got wire service play and ended up as a wall mural in a Boston disco!

If you want to work as a staff newspaper photographer, freelancing and stringing may be the best way to start. Full-time positions are few, but when one does open up, you'll have the experience to be considered. For regular freelance contributors, the daily newspaper can be a steady contributor to the income mix. But because of relatively low rates paid for photos, most freelancers will find it necessary to diversify.

Deborah Collings

Weather is no longer a feature but big news when it paralyzes a city. Freelancer Deborah Collings commandeered a jeep to shoot this blizzard and sold the photo to UPI. Adverse shooting conditions helped her sales by eliminating the competition!

Picture Needs

Daily newspaper photography can be divided into news events (planned news), spot news (unplanned news), features, sports, special sections, and the magazine (Sunday). Color is increasingly seen on the news pages in dailies, but black and white photography still predominates. Special sections and the magazine make extensive use of color.

News Events: Planned news events, when important enough, are covered by staff newspaper photographers. When the Pope visits, the whole photo department is assigned to cover the action. Instead of duplicating what the staffers bring in, the freelancer should look for unusual angles, a story within the story, and features. Parallel stories, secondary to the main news event, are called sidebars. News events can be anticipated by reading the newspaper, listening to news radio, and watching local television news. The schedules of politicians and celebrities are available from their press offices.

Spot News: Accidents, fires, and crime are spot news. Because spot news can happen anywhere at any time, photographers race to get the picture and rush it back to the newspaper to make the next edition. A news photo becomes stale and loses its value after a few days. To stay on top of breaking news, both freelance and staff newspaper photographers listen to scanners in their offices, cars, and homes. A scanner is a radio that monitors emergency frequencies used by police, fire departments, ambulances, and civil defense. When something happens, photographers listening to their scanners will arrive early enough to capture some of the action. If you get a spot news picture, immediately call the largest nearby daily and tell the news editor what you have.

Features: Newspapers run feature or human interest pictures to liven up the news pages. Be it a child's curbside

A photograph of a couple was used to illustrate a parenting story in a Sunday magazine. This photo was bought from stock files.

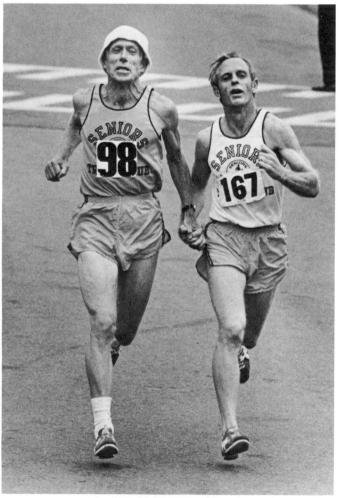

The sports event was the Boston Marathon. The news was who won. The feature was camaraderie.

The brig Beaver II crossing the Atlantic. Although this photo's news value has passed, its aesthetic value is lasting.

lemonade stand, an unusual occupation, or an idyllic landscape, features tell the story of everyday life. Readers love to be entertained by seeing how others work, play, and enjoy different lifestyles. The majority of features focus on people. Sensitive, interesting, unposed features are not easy to get, and a good feature shooter is an asset to a newspaper. Aspiring freelance photojournalists will get more work if they add artful features to their repertoire. Here are a some solid feature picture ideas:

- **Weather:** People enjoying good weather. Extreme heat, rain, snow, or wind, and how people cope with it. Weather is a feature photographer's best friend, as it is always changing, offering more opportunities.
- **Seasons:** The traditions, rituals, and chores we do seasonally. Raking leaves, carving the pumpkin, decorating the tree are all features that come with the seasons.
- **Children:** Many features capitalize on activities of children. Especially interesting are children imitating adults, children with pets, and having fun.
- **Unusual occupations:** Classic features have been made of chimney sweeps, farmers, and skyscraper window washers. Some unusual occupations can be used as feature stories offering in-depth coverage.
- **Animals:** Look for unusual pets, owner and pet look-alikes, and animals acting like people.

- **Hobbies and recreation:** Concentrate on the new and unusual, such as hang gliding, kite meets, box collecting, metal detecting, unicycling—anything that catches the eye or the imagination.

Sports: If the daily newspaper sends its staffers to cover the major events, the freelancer can cover the minor ones (high school and college athletics). Sports photography takes practice, timing, and concentration. In addition to the action on the playing field, also shoot "sideline" photos of the athletes and fans. Your photos are also valuable to the players, coaches, schools, and for team promotion.

Sunday Magazines: Sunday magazines make no bones about using freelancers. Although a staffer may be assigned to the magazine, freelancers with picture story experience and ideas are used regularly. Black and white and color pictures illustrate the magazines. The stories cover local, national, and international subjects, depending on the magazine. Weekday and Sunday sections may use freelance photographers with studio and specialized lighting skills. Foods, home interiors, artwork, and products must be attractively photographed for the papers. In spite of the large photo files built up over the years at daily newspapers, they are potential customers for your stock. When it's too expensive or impossible for a newspaper to assign a staffer to shoot, stock picture agencies and freelancers are contacted for the image. Subjects as diverse as the environment and computer technology, in black and white and color, are purchased for one time use.

Breaking In

Become familiar with the newspaper. Buy it, read it, recognize staff credits. See what types of freelance photos the newspaper buys. Compare them with what you've done and what you're doing now. Tailor your portfolio (see Chapter 3) to the news or magazine section.

At a large metropolitan daily, call the photo editor for an interview. At smaller dailies, ask for the news editor. Phone the Sunday magazine editor if you're trying to break in there.

After a successful interview, the news or photo editor is likely to say, "I like your pictures and I'm sure you're capable of doing newspaper work. There are no staff openings. We already have reliable freelancers we funnel assignment work to. If you're really interested, bring in some pictures I can use." That editor knows that most freelancers will never come back. The ones who do come back with pictures will get work. Go find some features or hunt up some spot news for this editor. That's how to break in.

To succeed with the Sunday section, you probably won't have to shoot a speculative picture story. Read about ideas and story proposals in Chapter 8. Put your brain to work for the magazine editor. Armed with a magazine portfolio and solid ideas, you stand a fair chance of landing some work.

Here are the best sources for local news, feature and story ideas:
• Daily newspapers; check calendar of events
• City magazines and entertainment guides
• Regional travel and recreation magazines
• Scanner to monitor police emergency frequencies
• News radio programs
• Television news
• Television evening magazine programs
• Press offices of celebrities and politicians
• Features and stories in any magazine may suggest ideas and applications to your market area

Kyle Bajakian

A pre-dawn phone call from the Marlboro (MA) Enterprise sent news photographer Kyle Bajakian to this house fire. House fires don't make national news unless there's a tragic loss of life, but they are important to local dailies. Pulitzer prize-winning photojournalist Brian Lanker once commented that he frequently smelled like a burning building.

Right: A celebrity for a minute, this freckle-face contest winner got national wire service play.

Pam Price

This photographer needed press credential access to capture Pope John Paul II in a moment of reflection. Most published photos of His Holiness were taken outdoors, where everyone could photograph him.

Ulrike Welsch, courtsey of Boston Globe

Prices and Terms

The rates paid by newspapers for photos depend partially on circulation. The larger the circulation, the higher the rates—theoretically. A news photo will sell for $10 at a small daily and maybe $50 at a large one. Front-page or news exclusives will pay more. Wire services pay from $10 to $25 per photo put on the wire. Newspaper rates vary according to budget, need, photographer's experience, and negotiation.

Sunday magazines are more consistent and more lucrative. They pay day rates for assignment shooting. When a Sunday magazine buys a stock photo, the rate is based on whether the picture is in color or black and white and how large the picture is on the page. A typical color Sunday magazine cover pays $300. One can assume that a Sunday magazine pays much more than news and slightly less than other magazines. A respected tool for pricing newspaper and Sunday section work is the ASMP Guidebook.

Prices fluctuate, but the terms under which freelance photographers sell to newspapers should not. All picture sales are one-time sales, and the negatives, prints, transparencies, and resale rights remain the property of the photographer. Unless you sign a work-for-hire agreement, don't let anyone tell you that you don't own your pictures, even if your client paid for the film. After you finish an assignment, carefully file your negatives and contact sheets. There is financial potential stored in those file cabinets—reprints for the subjects, resale of publication rights to other media or books, and stock agency royalties. Years from now, all your newspaper photography will be worth a lot of cash—a fact bemoaned by many staff photographers, whose pictures belong to the newspaper.

In the Field

Directed Assignment: **News**

1. Find a daily newspaper in your area for which you would like to work.

2. Study the way the newspaper uses pictures. Call the photo editor/news editor and ask if the paper ever buys freelance work. If so, proceed with directed assignment. If not, find another newspaper.

3. Using a newspaper listing or other source, photograph a scheduled morning news event of interest to both you and the newspaper. Shoot in depth, at least three 36-exposure rolls. Get names and addresses of subjects and other pertinent data.

4. Develop film and make contact sheets in early afternoon. Make three best prints. Caption.

5. Call photo editor/news editor and ask to drop off prints and contacts. If he or she is not interested, see the wire services.

6. When news value has faded, put prints into newspaper portfolio.

Technique: **Captioning**

All newspaper photographs need captions. Your reader will look at the photo and then go to the caption for more information and an explanation. Anticipate what the reader will want to know about your photograph. The five W's satisfy most captions: who, what, where, when, and why. The order of the five W's in your caption should depend on their importance and the point you are making with the picture.

Example: The President addressed the nation from the Oval Office of the White House today, regarding the situation in the Middle East. (The "who" is important here).

Example: The Middle East situation was the focus of a press briefing today at the Pentagon by the Joint Chiefs of Staff. (Here, the "what" is most important).

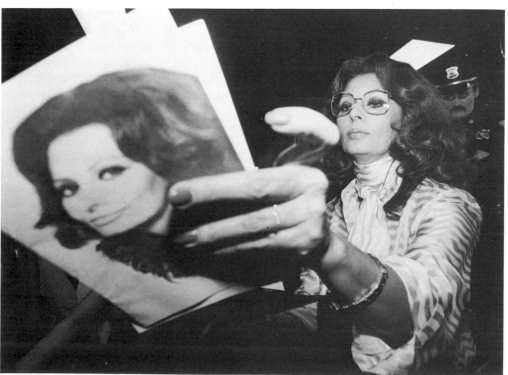

Repetion of image makes this picture work. Be it movie star or truck driver, the public wants to know—and see!

Pam Price

Profile:
Press Photographer at the White House

Pam Price worked her way through the ranks as a photojournalist. After getting a degree in communications at Emerson College (Boston, MA), she worked as a full-time shooter and darkroom technician for a chain of suburban weeklies. Next, while stringing for the UPI wire service in Boston, she got a staff position at the Providence Journal. Three years later, Pam is freelancing in Washington, D.C.

"It's horrible to say, but here in Washington, there's plenty of work in times of crisis and war. My work appears in LIFE, Time, and Newsweek, and in many newspapers. This week, I've been hired by the German magazine Der Spiegel to cover the White House and the Pentagon.

To make money in Washington, you have to pile up as many head shots of the President, congressmen, and cabinet members as possible. You shoot them at press conferences and committee meetings. What's important is to get the picture. I can't take any chances with equipment, so I own the very latest, quickest, and simplest camera. When it breaks, I throw it out. I use an automatic Nikon with auto winder, because you don't have time to manually advance film at a 10-15 second "photo op." I only use zoom lenses, because the press is restricted to fixed positions, and you must "zoom" to frame the picture. With a zoom, you also don't waste time changing lenses. I use Nikon 35-70 f/2.8 and 80-200 f/2.8 zooms.

A typical shoot of the President in the Oval Office starts with a call to the White House to get the schedule. I arrive in time for "open coverage," and wait outside with other members of the credentialed press, in groups called "waves." At the appointed time, I push through the door with the wave and rush to the Oval Office. Once there, I get a camera position as quickly as possible, focus, and shoot. I usually shoot continuously with the motor drive, and get about 18 frames fired off. "Lights" means the photo op is over, when the White House supplied tungsten lights are turned off. We know the drill, because we do it so often. The exposure with ASA 320 rated color tungsten film is 1/125 at f/3.5 in the Oval Office.

About 60% of my income is from stock sales of my pictures. Assignment work comes from my agent, The Picture Group, and from word of mouth. Fortunately, my husband also has a good job, because it would be difficult to support the family on my income alone. I earn part-time what many women earn full-time.

I've realized that freelancing is a good career for a woman who wants a family. You don't have to travel, once you've reached some level of achievement. For example, I went to Panama two weeks after the invasion, and didn't like being away. I told my agent what I would and wouldn't accept, and they understand. But you've got to get the grunt work done first—the 50 to 60 hour weeks, to call your own shots.

It's very difficult to be a freelance photographer and a mother, but I manage. The pressure increases when you add a child to the freelance load, and when I come in after a day of shooting, I'm tired, and of course my boy wants undivided attention. He's in day care 20 hours per week, and soon will be in regular school. I take off two days per week to be with him.

I like what I'm doing—it's exciting to be five feet away from the President, and it works well with my lifestyle. I'd like to have another baby and continue freelancing. And when the kids grow up and go to school, I can work full-time for a newspaper or wire service if I want to, or maybe be an editor.

As a woman, you can't give up everything for this business. If you do, you'll be aging and sitting there alone with your camera. It's key to believe that you can freelance, have a family, and make it work for you. Set your goals, and do it!"

Kevin Larkin

Her son Max on her shoulders, freelance photojournalist Pam Price covers a demonstration in Washington, D.C.

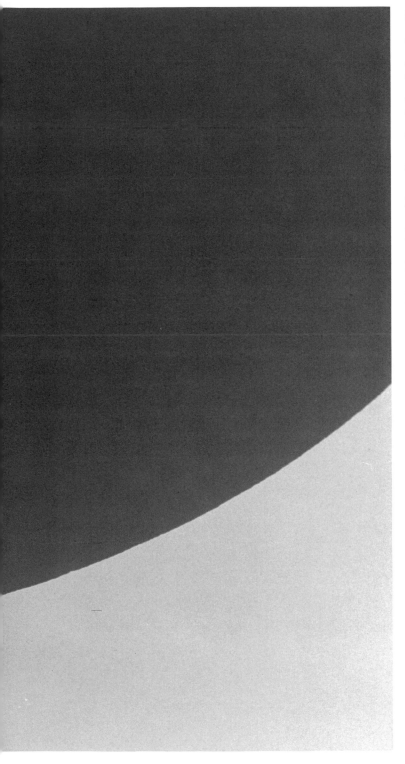

CHAPTER SEVEN
Educational Publishing Photography

The Market

Picture Needs

Breaking In

Prices and Terms

In the Field

Creative, documentary, and studio photography are all used in educational publishing. This fisheye lens picture was purchased as a wraparound color cover. Price: $500 for one-time use.

The Market

If you were in high school before 1970, you wouldn't believe how textbooks look today. I remember math books as page after page of numbers. Now they're filled with color photographs. Why? Educators know that pictures keep students interested in the subject matter. And textbook publishers sell more books by making their product more attractive and interesting—with extensive use of photography.

To get an idea of the scale we're talking about, peruse some textbooks at your library. A typical text will use hundreds of photos in black and white and in color. Multiply this by all grade levels, kindergarten through Ph.D., and all the competing publishers. Then consider the range of subjects: art, biology, business, chemistry, computers, driver education, earth science, economics, education, English, French, geography, German, health, history, Italian, Latin, law, literature, mathematics, medicine, psychology, physics, reading, sex education, social studies, Spanish, and all the trades. It is a huge market!

The people who buy photos for textbooks are called art editors and photo researchers. While textbook publishers usually employ staff photo researchers, many are turning to freelance researchers and independent photo research firms. These contractors are responsible for purchasing all of the photographs for a book, and may work in the publisher's office, or in their own office, sometimes hundreds of miles away. All photo research-

Many of the photo needs of the educational publishing industry are straight documentary. Life in the city can be your studio. If you enjoy photographing the world around you, plug into the textbook field.

Keep your eyes open around your home for textbook photos. What seems ordinary to us may be a fascinating phenomenon to an elementary school child. Even on the college level, literature and science books may use photos of frost on a windowpane.

ers go through the same steps when gathering pictures for a book.

First, they see what can be had from free sources, such as archives, chambers of commerce, industry publicity departments, and government agencies. Then they request specific subjects from stock photo agencies and from freelancer's files. Third, they fill all outstanding photo needs with assignment photography.

Few textbook publishers supply their own stock photos or employ full-time photographers. Without question, stock agencies and freelancers are the photo supply line for this market.

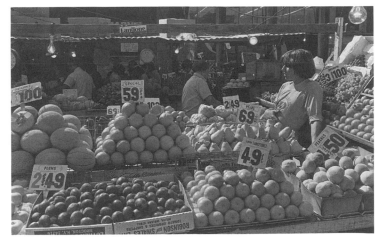

Math books now use photos extensively, attempting to link lessons with reality. Look for scenes showing numbers in action.

Civics textbooks show all levels of government, from local to national. The federal buildings in Washington, D.C. are used to illustrate the centralized national government, and town offices in your home town show local government. This town hall photo has sold about thirty times.

Picture Needs

Educational publishing photography has a style all its own. The pictures make a point very clearly—without innuendo, heavy symbolism, or distortion. This is especially important for grade school books. If a picture makes the same simple statement to different people, then it's a natural for textbooks.

What subjects are appropriate? Everything that is taught or is part of humanity's knowledge, history, or behavior will potentially appear in a textbook. I have sold the gamut from abstracts to zoos, from the preparation of squid to a horse tied up in front of a hospital. Perhaps it's easier to note what the textbook market won't buy: explicit sex.

I'm not suggesting that you go out and document the world. Concentrate on what is in high demand and low supply. Nature shots, for example, are in every photographer's files, and the publishing industry can only use so many. The freelancer who knows which picture needs are hardest to fill has a valuable marketing tool. Here are the three areas in which art editors have difficulties finding pictures:

Minorities: There aren't enough pictures of minority peoples in everyday life to go around. Art editors are required to use certain percentages of Black, Hispanic, Oriental, and Native American people in their books. This is because state textbook adoption committees—the people who review and order textbooks for entire public school systems—insist on accurate ethnic representation.

Settings for salable minority photographs range from family life to professional achievement. Show how minority peoples have been assimilated into mainstream, and also how they've preserved their cultural heritage.

Women: The sexes must also be equally represented in textbooks, not only in number, but in professional status. Unisex athletic teams, constructive community projects, and personal achievements are ways to picture young women. Older women can be shown in serious careers, especially those that are or have been male-dominated: construction engineer, doctor, forest ranger, lawyer, scientist, etc. A spinoff of this stereotype reversal is the picture need for men sharing domestic and family responsibilities. It is necessary to show Dad not in an apron, but rather feeding the kids, changing the baby, or doing housework.

Cities: Socially, culturally, and economically, American cities have a lot of photographic potential. They also have the largest market for textbooks. Unfortunately, many photographers turn their lenses elsewhere. I have been asked numerous times for a rush-hour crowd scene with ethnic diversity. Where are these pictures?

The city is a forum for social problems and solu-

Patterns and arrangements of everyday objects are the limit of abstractions for text photos. Don't forget that young school children are not as sophisticated visually as you are. The coiled hose was used to illustrate sentence structure.

tions. Aim your lens at slums and urban renewal, at traffic jams and public transportation, at strikes and the civic machine that makes cities work. I sell ten times more urban pictures than rural ones. If you want to shoot just landscapes, fine. If you want to make money and make useful photographs for education, then roll up your sleeves and document the city.

The textbook market uses black and white prints and color transparencies. The standard format is 35mm, except some covers and two page chapter openers, where 2 1/4 x 2 1/4 or 4 x 5 may be requested. Always use fine-grain color films, with ASA/ISO speeds of 25, 50, 64, or 100. Covers and openers pay the most, and are usually verticals, so be sure to shoot both horizontals and verticals when you come face to face with a good picture.

Most-Wanted Text Photographs

In addition to minorities, women, and cities, there are other "hot" subject areas for educational publishing. A freelance photographer could expect a good return from shooting some of the photographs listed below.

Agriculture: Major crops and methods of farming in regions, states, and countries; irrigation, contour farming, environmental concerns, farm life.

Alternative Energy: Conservation, geothermal, solar, wind, hydroelectric.

Business People: Especially minorities and women, in meetings, problem solving with co-workers.

Civics: Exteriors and inside workings of local, state, and federal government.

Community Projects: Environmental cleanups, neighborhood programs, informal neighbor-helping-neighbor.

Construction: Building of small homes and skyscrapers, minority and women engineers and forepersons.

Corporate: Life in the corporate world, benefits, interviews, meetings.

Crowds: Multiracial, varied ages, sexes, and economic strata. Sports fans.

Demonstrations: Issues of the day, such as AIDS, environment, peace, civil rights.

Education: Preschool to college—classes, interaction, team playing, continuing education, PTA, graduation.

Elderly: Active, happy, productive, interacting with young people.

Energy: Coal and oil production, power plants, storage, transportation; nuclear power plants. Energy saving and over consumption.

Erosion: Beach, mountain, and river erosion in nature and affecting mankind.

Family: Activities, chores, life-style, and portraits. Twins, two and three generations together. Especially minorities.

Handicapped: Active, constructive, meeting challenges, and also temporarily handicapped, such as a broken arm.

Health Care: Home diet, exercise, weight loss; clinics, labs, and hospitals, especially with model releases.

High Tech: Use of computers and other tools in home, industry, and education.

Housing: Lower, middle, and upper class apartments, condominiums, and homes in suburbs and cities; mobile homes and the homeless.

Languages: People, scenes and signs for foreign language textbooks—French, German, Italian, and Spanish, both in the U.S. and abroad.

Measurement: Metric signs, especially those that convert easily to U.S. equivalent; thermometers and other measuring devices.

National Monuments: In Washington, D.C. and elsewhere. Dramatic, with and without people.

Parenting: The stages of rearing children, single parent families, second marriage families with step-children, fathers taking an active role.

Politics: Campaigning, polling on the street and by telephone, and voting.

Pollution: Acid rain, air, hazardous waste sites, litter, nuclear, oil spills, water, and cleanup efforts.

Progress: Contrast and clash of old and new cultures, technologies.

Recycling: Glass, metal, paper, and plastic at recycling centers and at home; solid waste dumps.

Skylines: Constantly updated city views, day and night.

Traffic: Congestion and pollution; car pools.

Transportation: Public and commercial; bicycle, bus, plane, ship, and train.

Weather: Types of clouds, falling rain and snow, extremes, how people adapt.

Work: Careers, especially minorities and women.

Breaking In

Although most large publishing houses are located around large urban areas, some have decentralized various divisions and moved them out of the city. Smaller publishers are also likely to be in outlying areas. Book publishers are listed in the Yellow Pages under "Publishers, Book." Independent photo researchers, who are increasingly handling picture buying for publishers, are located anywhere you can hook up a phone and a fax, and have mail delivered. Photo researchers are more difficult to locate. Write to the American Society of Picture Professionals (address and phone number listed at the end of The Freelancer's Handbook), a national organization of photo buyers and sellers, for their membership directory.

Publishing companies have favorite methods of interviewing freelance photographers. Some have an interviewer who screens out inappropriate portfolios for reasons of quality or subject matter. The interviewer can also steer the freelancer to the people who are buying photos for a project.

At other publishing companies the freelancer must contact the photo researcher directly for an appointment. You'll probably end up with a senior researcher who has experience in evaluating portfolios. Still other companies will have the whole photo research team see your work at once.

Before you call for an appointment, be certain to have an educational publishing portfolio. Know what kinds of books and photographs go through the publishing house. If you can't get your hands on one of the

company's texts, ask to visit the company library. It's your business to know their business.

To get a good idea of what a portfolio should contain, check out the sample educational portfolio in Chapter 3. To be safe, you should make sure that at least half of your pictures are from the Most-Wanted Text Photographs list, unless your research indicates otherwise. I have a special educational publishing portfolio filled with photos that art editors scramble for. When they see ready solutions to their photo research problems in your portfolio, you've got a new client.

The biggest problem freelancers have with publishers is being remembered. Art editors see so many photographers and get so busy that they need to be reminded. A business card is a minimum reminder. A stock list is even better. To make stock sales, you must give your client information about your files. Photographic promotion pieces are excellent ways of staying fresh in a client's mind. Try making a photo postcard or calendar. You can make calendars inexpensively in your darkroom using special calendar masks, available from photographic specialty stores.

When breaking into the educational market, you can play one last trump card. Textbook photos often require setups with kids. The models must be of a certain age, sex, and race. Recruitment of models is a frequent problem for the art editor and photographer. Make it known that you have access to models. It will be appreciated. One less headache for your client might be one more job for you.

Nuclear power plant, fossil fuel plant, and "filling up the tank" all fall into the Most-Wanted Text Photo "energy" category. And each has sold at least once. Put pictures like this in your textbook portfolio to get work, then put them into your files for stock photo sales.

Prices and Terms

The space rates paid by educational publishers for stock photography are fairly consistent. Large publishers and many smaller ones follow the rates suggested in the past by ASMP, but which ASMP unfortunately no longer publishes. Black and white starts at $135 for a quarter page, and color at $175. Pricing gets more complicated and higher when you sell chapter openers,

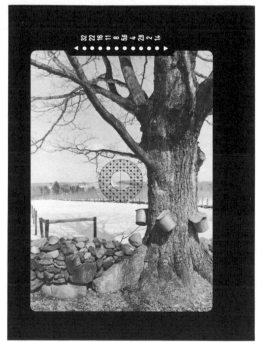

When a good photo possibility jumps out at you, shoot it both horizontally and vertically, shoot it in color and black and white, shoot it until it's dead! One never knows what a publisher's design requirements will be, so it's advantageous to have variety. Also, having a good picture in quantity lets you supply your stock agency and have leftovers to send out yourself.

frontispieces, foreign language or world rights, or advertising rights. For these situations, you'll have to query local photographers, publishers, and stock agencies. A valuable reference is Jim Pickerell's Negotiating Stock Photo Prices. Make sure you charge for all rights being purchased.

Day assignment rates vary with the publisher, the complexity of the assignment, and the experience of the photographer. Rates range from $350 per day for the starting freelancer to $1,200 for the seasoned pro with a studio. Not only are day rates themselves negotiable, but how much work you can do in a day is up for grabs. What an art editor estimates as one day's work might be renegotiated by you to one and one half days' shooting. Always negotiate *before* taking the job.

When publishers buy stock photos, they are buying one-time, nonexclusive rights. The photographer gets the picture back and can resell it to anyone, at any time. It's not standard practice to sell exclusive publication rights to a publisher, and I don't advise it. If you must, start negotiating at 250 percent above recommended space rates.

Some publishers want to place restrictions on assignment work given to freelancers to prevent the picture ending up in a competitor's book. Restrictions may include not reselling the photo or out-takes (similar images taken during the shoot) for a certain period of time, not reselling to competing publishers, or not reselling within the textbook industry.

While experienced freelance photographers can walk away from restrictive contracts, the beginning freelancer ends up in a bind. On one hand, you need the experience and the money. On the other hand, you know you're losing future stock sales without extra compensation. This is what the beginning freelancer can do:

- Evaluate the severity of the restrictions. If they only exclude sales to competing texts in the same subject area for five years or less—live with it. Take the job and take the money.
- Offer a discount in exchange for no restrictions.
- When publishers demand exclusive rights (you cannot resell the photo—ever), they'll ask you to sign a work-for-hire agreement. Accept the job only if it's an opportunity you've been waiting for. Sign the agreement to get experience and put published work into your portfolio. Then start looking for better clients.

Your foreign travel, especially to French, German and Spanish speaking countries, can be used to illustrate language books. Before you go, call your textbook publishing contacts to see if any foreign language projects are coming up. If so, try to get a list of photo specifications, which you can shoot on speculation. Chateau Chenonceaux, and other photographs I took in France, sold to a publisher within weeks of my return.

Your photo files from newspaper and magazine assignments may be particularly marketable to the textbook industry. Documentary pictures of people, issues, occupations, and the way we live are constantly requested by publishers.

In the Field

Directed Assignment: **Educational Publishing**

Put aside an entire day for this assignment. Don't schedule anything other than taking pictures. This will be an eight-hour workday.

1. Select from the Most-Wanted Text Photographs list five subjects that can be found in your area.

2. Logically determine the day's shooting schedule. Consider driving distance, lighting, business hours, and lunch.

3. Make appointments where necessary to confirm schedule.

4. Write down the day's plan. It might look like this:

9:30 a.m. (Energy) Photograph exterior of Plymouth Nuclear Power Plant. Lighting best in morning.

11:30 a.m. (Pollution, recycling) Shoot Nut Island Sewage Treatment Facility. Public tour of interior starts at 12 noon.

1:30 p.m. (City Crowds) Show workers on street after lunch in downtown Boston. Try shots from walls, plazas, and across streets.

Lunch for Photographer. No martinis, please.

3:00 p.m. (Elementary School) Photograph Parent Teachers' Association fund-raising fair. Photograph boys and girls participating together in contests. Get left-to-rights for possible sale as feature in newspaper. Leave card with PTA president. Make note of potential textbook models.

5:00 p.m. (Traffic) Shoot bumper-to-bumper rush hour traffic. Use telephoto lens from overpass.

5. Shoot your assignments in black and white and color and in horizontals and verticals, and bracket all exposures. Expose at least one roll of film at each event.

6. Print the best ten black and white negatives. Fill one slide sheet with color.

If your results compare with what you see in textbooks, make an appointment to show your portfolio. Set up another shooting day like this one. With persistence, you can't help but become a better photographer and an educational stock photo resource.

Client's Viewpoint

Connie Komack
Pictures & Words
P.O. Box 371, Rockport, MA 01966
(508) 546-3028

I have been in the textbook business for twenty-two years, having worked on staff for three major publishers in the Boston area. I have been a photo editor, photo researcher, art editor/designer, and science editor. My most recent job was as Photo Coordinator for D. C. Heath and Company (Lexington, MA). Presently, I have my own business, Pictures & Words, which provides picture research and assignment photography production, writing and editing services to publishers, and consulting services to photographers.

As a freelancer, your portfolio should contain examples of the range of your work, showing content, approach, and technical ability. The pictures should, of course, be relevant to the textbook field. They should reflect your current interests and specialties. Do not include examples of work that you don't like to do.

If you're really interested in this field, investigate educational publications. Look at textbooks. Take the time to talk to photo editors in your area. Show your work, get feedback, improve it, and come back again.

Your initial phone contact should be short, pleasant, and to the point. Introduce yourself and offer to send materials. If you're local, ask for an appointment to show your portfolio. I don't like to receive material that has to be returned unless I ask for it, and I never appreciate unsolicited photographs. Include a short, informative cover letter highlighting your special interests and skills, and a one or two page stock list. Also include your business card, Rolodex card, brochure, or flyer if you have one. Publishers keep this material on file, and when they need you, they'll call.

People who are pleasant and easy to work with are high on my list of priorities. I enjoy working with photographers who are technically competent, flexible, personable, and really interested in working in educational publishing. I look for a well-developed specialty (for example: chemistry, children, or nature) or a broad and deep general file. I need photographers who have experience and have mastery of technical skills, including lighting and composition.

Another asset for photographers is a good eye for the kind of subject matter that educational publishers use. Photographs should be clear, and their point obvious to the viewer. When photos include people, educational publishers are usually looking for attractive, well-groomed subjects with current, but not faddish clothing. Good gender balance should be evident, as well as representation of African-Americans, Hispanics, Native Americans, and Orientals. Usually, contemporary photos will be rejected for textbook use if they show people smoking, drinking or using drugs, show nudity or explicit sex, brand names of products or advertising, or show derogatory treatment of people. Unless making an historical point, avoid clothing, objects, or backgrounds that will too quickly date the photo.

More and more frequently, publishers are requesting very quick turnarounds. Most business is conducted by phone, fax, and overnight couriers, and it's not uncommon for a publisher to need to receive photos overnight or within a couple of days of requesting them. Yet, once received, the photos often go through an elaborate selection process, sometimes taking weeks or months, and selected photos may be held for as much as a year or so. Prompt response, patience, flexibility, and an understanding of the textbook production cycle are important assets for the freelance photographer.

Be careful to package your photographs professionally when shipping them to a publisher. Include complete captions and a delivery memo. And unless advised otherwise, send originals. I recently opened a package containing 100 slides with no captions and no photographer identification on them, and they were obviously duplicates. I sent the package back without even looking at the photos.

Some very successful photographers are primarily textbook photographers. The rate scale for textbook photos isn't as high as for advertising and not as low as some small magazines—it's about in the middle. But the volume of photos in a textbook is much higher than magazines. The typical textbook has 300 to 500 photographs in it.

There's another reason to go into educational publishing. Some photographers have deliberately chosen the field because they're committed to quality education, accurate learning materials, and showing people in a positive light. They enjoy textbook photography for its own sake, not just as a stepping stone.

CHAPTER EIGHT
Magazine Photography

The Market

Breaking In

The Idea Bank

Proposing a Story

Prices and Terms

In the Field

No matter what your interest is, there is probably a magazine that covers it. Not all magazine photography is of celebrities or exotic places. Basic "how-to" and everyday life stories compose the majority of magazine stories.

The Market

The doom of the magazine market was prematurely forecast with the death of *LIFE*. Alvin Toffler, author of *Future Shock*, cites the breakup of huge communications conglomerates such as large magazines, and notes the growth of small and diverse publications. He explains that small printing runs are made possible by new technologies. Thus, *LIFE* is back and magazines are more numerous than ever. The broad range of magazines is best described by the type of readership they serve.

General Interest: Like *LIFE*, these magazines are large in circulation and picture usage. They cover national and international news, life-styles, trends, fashion, personalities, sports, and features. *Time* and *Newsweek* also include medicine, religion, art, and the economy. Any newsworthy or interesting subject is candidate for general-interest magazines.

Special Interest: A magazine exists on almost any subject you can think of—from science to cooking, from surfing to organic gardening. These magazines are targeted to readers who seek detailed information about one subject, be it antiques, hot rods, or running.

Regional: Geographic, state, and city regions are the focus of magazines such as *Yankee, Arizona Highways,* and *New York*. The readers live, have lived, want to live, or are just plain interested in the territory covered by regional magazines. For instance, *Yankee* covers New England, but most of its readership lives elsewhere.

Religious: Church-related magazines aren't always preaching doctrine. Instead, they deal with family life, growing up, and everyday issues of morality. Religious publications strive to be relevant, contemporary, and interesting, especially to young people.

Corporate: Many companies publish magazines for their employees, customers, stockholders, and business friends. The photos and stories do not necessarily have a product tie-in; some include scenic, recreational, or how-to stories for their readers. Airline "in-flight" magazines promote the airlines and run features on their destinations.

Trade and Club: Trade journals are circulated to members of a particular profession. Bankers, for instance, read *Banking*. Club publications are sent to people belonging to clubs, associations, and certain credit-card holders. Trade and club magazines cover the gamut of professions and interests. Nearly all rely on freelance photographers.

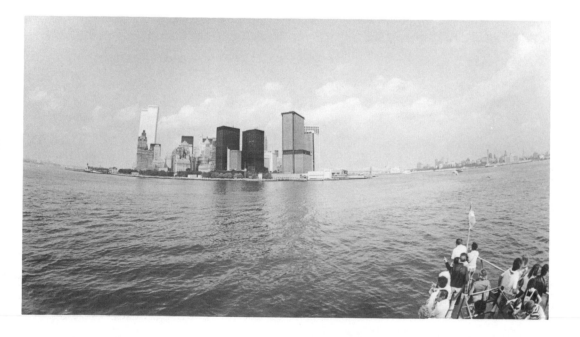

Tourism is on the rise. It is the world's second largest industry. The number of travel magazines will grow accordingly, and so will the freelancer's travel/recreation client list. Look for city, state, regional, and national travel magazines. Tourist service magazines—hotel chain magazines, automobile-related publications, bus, train, and in-flight magazines—are other users of travel photos.

The editor, designer, and photographer all leave their mark on the magazine page. The photographer can foster or inhibit good picture usage by controlling the selection of photos he or she submits. Supply as much subject variation as you can. Include an overall shot for viewer orientation. Get medium-distance photos with lots of people. Finally, bring some close-ups—they can give the designer layout alternatives.

Breaking In

There are as many picture needs in this market as there are magazines. You must analyze every magazine's needs on an individual basis. Don't assume that one approach will work for all magazines. Unlike the textbook market, which shares industry-wide picture needs, each magazine requires a tailored portfolio and targeted research. Freelance photographers fail to get magazine work because they think "a magazine's a magazine, right?" Wrong. If you really want to do magazine photography, you must do some homework.

The strategy for magazine work is a three-pronged attack: Convince the editors with your portfolio that you can do assignment work; lure them with relevant stock photos; knock them out with your ideas.

Steps to Magazine Work

- **Determine** the fields of your personal and/or photographic interest. Take the "Interest Self-Test" in Chapter 1. It is much easier to work for a magazine whose subject area interests you and about which you have some knowledge than it is to work for one that you know nothing about.

- **Locate** magazines in your field of interest.

a. Peruse and buy magazines of interest on the newsstand.
b. Libraries have periodical sections with back issues. Sit down and read. Take notes, because magazines don't circulate.
c. Study photo market and writer's market resource books—Photographer's Market (Writer's Digest Books, Cincinnati) is a good one. It lists magazines of all types with basic descriptions, rates, addresses, and phone numbers.
d. The Yellow Pages for your area lists magazines under "Publishers—Periodical." Also check Associations Athletic Organizations, Business and Trade Organizations, Church Organizations, Clubs, Environmental Organizations, Labor Organizations, Political Organizations, Publishers—Directory and Guide, and Youth Organizations.

- **Research** target magazines

a. Consult photo market resource books.
b. Buy or write for sample copy. Write magazine for photographer's and writer's guidelines.
c. Study all available issues.
d. Enter research data onto a copy of Photo Market Analysis, which you'll find at the end of Chapter 4.

- **Assemble** a tailored portfolio. Read Chapter 3. Do not overlook this step. If you have no relevant photographs, you will find that it's worth it to shoot some if you really want the job. If you have doubts about the quality of your pictures, read "Where Are You Technically" and "Skill Correlation Guide" in Chapter 1.

- **List** exciting story ideas suitable for the target magazine, based on your research. Read "The Idea Bank" in this chapter.

- **Call** to schedule interview. If magazine is too distant for personal visit, call to introduce yourself and prepare the editor for your submission. Inquire about last-minute photo needs.

- **Interview**. Make sure you've read Chapter 4.

- **Submit** stock photos, if requested.

- **Query** about more story ideas.

- **Write** story proposals for queries that have stirred up interest.

- **Maintain** flow of new work and ideas.

A Note on Speculation

Some magazines will ask that you do your first story for them on speculation. I suggest going along with this, especially if the magazine is respected and if you have a limited track record.

Don't confuse speculation with portfolio preparation. When your target magazine is one that does twenty-page spreads on one story, the editor will want to see in-depth studies in your portfolio. Without the in-depth component, your portfolio falls short of being tailored for this magazine. It may be necessary for you to shoot an extended piece to put yourself in its league.

When you're on the road for a magazine, be prepared for anything. A science museum assured me that no planetarium photo had ever come out, nor would one ever do so. With that encouragement in mind, I grabbed some passing tourists and talked them into watching the show while I photographed. Gift prints were sent to the models and the science museum.

Computer magazines comprise a healthy segment of the magazine market. Because hardware alone can be tedious, editors prefer to feature the personalities behind the technology. The portrait of software innovator Mitch Kapor, founder of Lotus Development Corporation, was shot as an InfoWorld cover.

The Idea Bank

Editor after editor has told me that freelance photographers who have story ideas are priceless. Robert Gilka, former photography director for *National Geographic*, said that his magazine is "up to our eyebrows in talent, but only up to our ankles in ideas." All magazines are receptive to ideas, whether they come from writers or photographers.

Editors encourage story ideas from photographers for several reasons. When all the staff ideas have been used up, outside suggestions are crucial. You have seen places and met people the staff members haven't. You have distilled knowledge from all the books, magazines, and newspapers you've read. Your approach to the same old story may be unique. Most important, the photographer's eye is adept at recognizing good picture possibilities.

Why spend time thinking up story ideas when you could be shooting? Mainly because you'll get work faster, and more of it. Waiting for the phone to ring is not productive. Feeding ideas to your editor betters your chances of landing an assignment. Also, shooting a story based on your own idea is likely to be more interesting than one on someone else's idea.

When you contribute to the idea bank, a return is imminent. A magazine cannot function without good ideas. Your input will open doors and keep work coming, because you offer more.

Which Ideas Fit?

It's your responsibility to determine which ideas are appropriate for a particular magazine. When you write for the photographer's guidelines, request the guidelines for writers also. They probably contain more editorial and idea information. If you're still wondering if your ideas fit a magazine, call the editor and ask. "I've got some story ideas. Could you tell me if I'm on the right track?"

After a few of your queries are rejected, you'll develop a sense of which ideas will move and which won't. I've gotten to know some magazines so well that whenever I need some work, I think up some good ideas for stories. When I want to break into a new magazine, I start thinking again...

I am interested in historic seaports and antique steam locomotives. Perhaps this fervor comes through to an editor in a story proposal. After the Essex, Connecticut, proposal was accepted, my interest in the subject made the assignment more satisfying, and the pictures had some heart.

Where to Find Ideas

Newspapers: Read newspapers in your area for events, profiles, and locations. Read newspapers from anywhere in the world to suggest ideas for your magazine. A forty-word article on fur trapping, buried on page 38 of the *Boston Globe*, suggested a story idea to me. I passed it on to a magazine.

Magazines: Short articles or listings in your target magazine could be expanded into full-length stories. Similar magazines can spark an idea. The trick is to translate the original idea into one you can market. I study *LIFE* magazines from the 1940's for ideas. Check out Japanese magazines for excitement!

Books: By reading about the subject or area you want to photograph, you'll become an expert compared to other photographers. Books are filled with ideas and details to back them up. I wanted to photograph New England for regional and national publications, so I started a resource library. References such as A Guide to New England's Landscape were directly responsible for magazine assignments.

Radio: Listen to news radio for events and features that can be turned into picture stories. Some stations have "sight and sound" reports from roving reporters, who dig up interesting recreational ideas.

Television: A constant flow of magazine ideas will come from TV if you watch the right programs. Tune in news, local TV magazine shows, documentaries, talk shows, how-to programs, travelogs, public television and local cable channels.

Travel: Ever notice how someone who has traveled a lot has a wealth of stories to tell? Travel is the best education you can get. If you've seen it, or photographed it, you're in a great position to propose it to a magazine. I keep a small file on every country I've visited. Into it I put maps, tour guides, brochures from parks, hotels, and restaurants, names and addresses of people I've met, and any good stories I've read about the country. The files are a source of ideas and also have the caption information for my photos: "How do you spell the name of that mining town in arctic Norway?"

Friends: Don't overlook your friends as sources of ideas. They have specialized knowledge about things you never knew existed. Take a friend out for a beer and explain what kinds of ideas you're looking for. Don't forget a note pad, or you'll have to resort to napkins or matchbook covers!

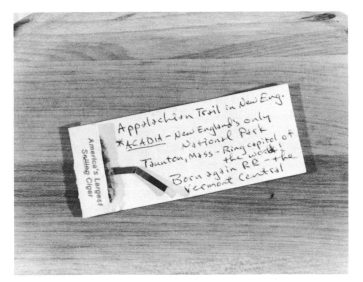

Sipping a drink with a well-traveled friend can stir up good story ideas. I took notes on a matchbook cover while talking to one friend, who mentioned Acadia National Park—an idea that was accepted by Yankee *magazine. The other ideas are awaiting development.*

Brainstorm with a Writer: Writers are valuable people for photographers to know. Sit down with a writer, preferably one with a track record. Find the intersection of your interests and target magazines. Fantasize, scheme, talk about contacts, successes, and failures. Approach the magazines with your ideas as a team. Brainstorming with a writer has produced a magazine story every time I've tried it.

Idea File: Good ideas are fleeting. If no market comes to mind, or if you're too busy to act on an idea, clip it or write it down. File the idea in an idea file. Later, as new magazine markets rear their heads, you'll have a little Fort Knox of ideas.

Proposing a Story

The Query

Good ideas must be properly channeled to an editor. A query is a presentation of your idea with just enough facts to make it sound interesting. Gather information to support your enthusiasm for the idea. It might take a phone call or some light reading to do this. Confirm your understanding of the facts. Without having done extensive research, you are now in a position to get a green or red light on your idea.

Queries can be presented in writing from two sentences to two paragraphs long. Written queries are best when you don't know the editor, or when you're querying a few ideas at once. Always type your query and make sure to send the original.

If the editor knows you from an interview or job, telephone queries can be quick and effective. You can also make verbal queries during interviews. What you want to hear is "that sounds like a good idea to me. Write up a proposal. If it still looks good, we'll do it" (green light). You may hear, "I'm not convinced the idea is for us. Send some more information and we'll discuss it" (yellow light). The red light is "Thanks, but we ran a similar story three years ago." Occasionally, a query will get you an assignment right off the bat.

Examine the following sample queries and see if any would fit your target magazine.

"New York City has so many farmers that the U.S. government has set up an agricultural extension service. Urban gardening is now taking place on a large scale in several neighborhoods."

"I would like to suggest a story on Boston's Faneuil Hall Markets. The three Greek Revival buildings have served commerce and shoppers since 1826. Faneuil Hall is now a National Landmark and the second most popular tourist attraction in the USA."

"Taunton, Massachusets, is the ring capital of the world..."

The Story Proposal

When the editor takes the bait offered by your query, it's time to set the hook with a story proposal. The purpose and parts of the proposal are threefold: (1) to convince the editor that readers would be interested in this story; (2) to provide sufficient background data to prove there's enough material for a story; and (3) to explain, in visual terms, how you intend to go about photographing this story.

Begin your proposal like a magazine article, with a lead sentence or "hook." Your first sentence must grab the reader's attention with the most exciting or unusual aspect of the story. The theory is that if you don't hook your reader at the start, you've lost his or her interest. The editor must be affected by your proposal right away. Look over my sample queries. They all contain a hook. If you can't think of a hook for your proposal, ask yourself if it's such an interesting idea after all.

Here is a hook I used in a story proposal:

"The Great Swamp, in South County, is Rhode Island's last wilderness. It is a 3,000-acre management area and refuge for some nearly extinct plants and animals."

The body of your proposal should follow the hook. You must show the editor that there's enough "meat" or depth to justify the story. To get the necessary details, you'll have to do some research. Look into every reference source you can. Become an authority on the subject. Some photographers list picture possibilities. In short, make a very good argument for your case that you have a great story. If you don't, be prepared to hear, "we just don't feel there's a story here..."

Let's continue the Great Swamp proposal with some details.

"The impenetrable undergrowth is a haven for rare holly trees and club mosses, both of which are protected by state law. Ospreys nest in the Great Swamp, along with green heron, kingfishers, Canadian geese, grouse, and woodcocks."

The tail end of your proposal should outline your photographic approach to the story. Are you going to be positive or negative? How long will you spend on the shoot, and during what season? What flavor or tone will the pictures have? Reveal the message or importance your essay will hold for the readers. Let the editor know what you're up to.

This was my focus in the Great Swamp:

"I propose to photograph the Great Swamp from the naturalist's viewpoint, featuring the rare plants and animals that few people have seen. The essay will also cover swamp wildlife biologists in an active role. I would like to photograph the Great Swamp in spring, midsummer and fall."

Your proposal must be carefully composed and typewritten. Always keep a copy for yourself. If the idea is rejected, note the date and publication on the proposal copy. If you believe it is a good proposal, rewrite it for another magazine.

Simultaneous submissions, or sending the same proposal to more than one magazine at once, is a tricky business. Some magazines don't mind simultaneous submissions, and indicate that in their guidelines or in photo market resource books. Sending an editor a photocopy or carbon is a dead giveaway that the proposal is sitting on someone else's desk, too. Send an original. If your proposal is accepted by two competing magazines at once, you'll probably end up losing one or both clients. Be careful.

Some photographers worry that magazines will steal their ideas. I won't say that nobody ever steals, but my experience has been that editors are loathe to alienate photographers who have ideas. When you see a story you proposed appear in a magazine, that at least indicates that your thinking is parallel with the magazine's. In all probability the story was scheduled independently of your proposal. So give the magazine another shot.

Finding a wildlife biologist added depth to the Great Swamp story, Her duties in the swamp made interesting pictures. She was also a source of information on the swamp and its inhabitants.

Prices and Terms

Magazines have two ways of paying freelancers. For stock photos and one-photo assignments, they apply a "space rate," or "page rate." Space rates are set by the publication, and how much you get paid depends on how large the picture is on the page and whether it is black and white or color. Space rates vary according to the circulation of the magazine. The ASMP Guidebook can help determine whether you're getting a fair space rate.

Picture stories are assigned on a day-rate basis. The editor and photographer estimate how long it will take to shoot the job in half-day increments (1/2 day, 1 day, 1 1/2 day, 2 days, etc.). A half day does not pay 50 percent of your day rate; it usually bills at 66 percent of the full day rate. If the magazine has not established day rates, then you must negotiate. Again, consult the ASMP Guidebook.

To be fair and to offer incentives, some magazines will hold your day rate against the space rate. This means that you will be paid a space rate for your photos if it exceeds the day rate you were paid for the assignment. Let's say a magazine hires you to shoot a story in one day for $250. The editors like your photos so much they run five full pages of your work. Offering a space rate of $100 per page, they use $500 worth of pictures. When the day rate is held against the space rate, you get the $250 difference in addition to your day rate.

Expenses should be paid on top of your shooting fee. Assignment expenses include film, processing, mileage, shipping, and any other miscellaneous arrangements. If an overnight stay is necessary, add meals and lodging to your expenses. You can negotiate the time spent getting to your assignment location, or travel time, at 50 percent of your day rate. You can similarly negotiate time spent waiting out rainy weather.

It may happen that you'll shoot a magazine assignment satisfactorily, and then the editor will decide not to run it, through no fault of yours. In this event, a "kill fee" is applied. The kill fee is 50 percent of your shooting fee and 100 percent of the expenses.

When a freelance photographer shoots an assignment for a magazine, it should be clear that he or she is selling one-time non-exlusive reproduction rights. All negatives, prints, and original transparencies are the photographer's property, whether they are published or not. You'll find that most magazines subscribe to this procedure, which is supported by ASMP.

Some publications, however, request more than one-time non-exlusive reproduction rights from assignment photos. Some wish to retain only published photographs. Others will return the entire shoot if you request it. Legally, all photos are yours unless you sign a work-for-hire agreement. Remember that you and your stock agency can resell assignment photos individually and as picture stories. Don't give them away.

The fisherman statue is the most obvious and most photographed symbol of Gloucester, Massachusetts. On a story assignment, cover the exotic, the unusual, the undiscovered. But don't overlook the obvious. Out of all the unique and creative photos taken in Gloucester, my client chose to run the fisherman statue.

Technique: Lens Choice

Magazines are the showplace of lens virtuosity. Because photos are often seen side by side in magazines, shooting with different focal-length lenses introduces variety. Also, the various situations that come up during an assignment require you to select a lens to do the job properly. Good lens use gets the visual message across and does it creatively.

Wide-Angle Lenses range from fisheye (6mm) to 35mm. Wide-angle lenses are used to cover a tight situation when you can't step back, such as a conference in a small room. With wide-angles you get lots of depth of field, the ability to focus very close to an object, and consequently the enlargement of objects that are close to the camera. These characteristics can be used to add emphasis and to pack in-focus information into a picture. Lenses wider than 35mm can seem to distort the shape of your subject if you're not careful. Used properly, distortion can be a graphic tool. I get more use out of my 35mm lens than any other, and so do most of the editorial photographers I know. The 35mm lens is an excellent first lens.

Normal Lenses come with most cameras when you buy them, whether you want them or not. A 50mm or 55mm focal length lens is considered normal. A normal lens can come in handy for its speed (f1.2 or f1.4). Although it is a bit slower (f3.5 or so), I would rather have a 50mm or 55mm macro (also called micro) lens. A macro lens will focus from infinity to within a few inches of the subject. The lens by itself will get close enough to produce a quality 1:2 (half life-size) image. With an extension tube added you can get a 1:1 (life size) image. I like being able to make close-ups without fussing around with attachments.

Telephotos come in 85mm through 2000mm and longer. My most useful telephoto is the 85mm. It is fast (f1.8) and a great lens for portraits. I advise photographers to start with an 85mm or 105mm telephoto. Buy longer lenses only as you need them. Besides bringing your subject in closer, telephotos compress the distance between two objects—another graphic tool for photographers.

Zooms are variable-focal-length lenses. There's quite a variety of zoom ranges, but most of them fall into the wide angle to short telephoto category (such as 35mm-105mm) and short to long telephoto (such as 80mm-200mm). The advantages of these lenses are the ability to frame accurately without moving, and cutting down on the number of lenses you have to carry.

The biggest problem is difficult and slow focusing. Your particular application, be it portraits or sports, should determine which zoom lens you buy. Today's generation of zooms is faster, lighter, and sharper than previous ones. Just be sure to buy a quality lens and confirm that it's a sharp one.

To add drama, use a telephoto lens to pack the foreground and background close together. A 180mm telephoto was used to tighten the space from the fence to the White House, providing a visual link.

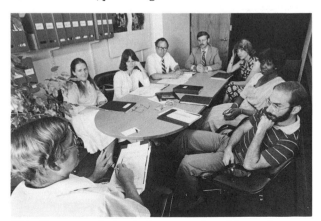

This illustrates the basic function of a wide-angle lens—to fit the subject all into the picture.

In the Field

Directed Assignment: Magazines

1. Find an accessible magazine that interests you. It should be within reach of your skill level and photo experiences.

2. Research this publication. Enter data into Photo Market Analysis (see Chapter 4). Study photo market resource books and write for guidelines.

3. List three exciting story ideas (exciting for the readers and the photographer) for the magazine.

4. Develop one idea into a story proposal. Gather enough information to fill one typewritten page (double-spaced).

5. Shoot the most photogenic story idea thoroughly, as if it were an assignment for the chosen publication.

6. Approach the magazine, as outlined in "Steps to Magazine Work" (see p. 80).

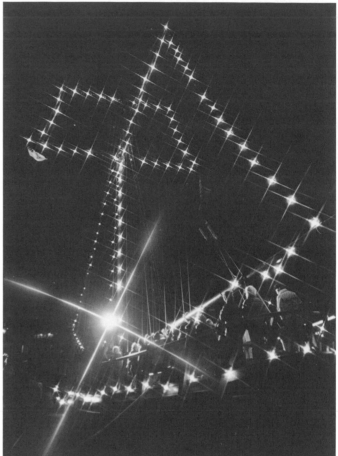

Relying solely on special effects is risky business, especially in the magazine field. This night photo of a sailing ship, taken with a star filter, is one of the few special-effect photos I've had a magazine use. Make sure you've got the basic shots first, then try a special effect if it will enhance the photograph.

More magazines are filling their pages with stock photographs instead of hiring photographers for assignments. It's cheaper, the editor knows what the stock photo looks like and has it in hand, and winter pictures can be secured from stock in summer. I make sure that my magazine clients know I have stock available. It costs only a few hundred dollars to use this photograph in a publication, but would cost a few thousand to fly me to Bryce Canyon in Utah to take it!

Client's Viewpoint

Ms. Joni Praded
Director of Publications
The Massachusetts Society for the
Prevention of Cruelty to Animals
Director and Editor, *ANIMALS* Magazine

The MSPCA's national bi-monthly magazine, *Animals*, and its annual calendar both use photos from freelance photographers. People send us unsolicited material such as prints and slides through the mail. This practice is not advisable, particularly the sending of originals. Not only are our chances of using unsolicited work very small, but we get such an enormous amount of material we simply can't be held liable for its safety or return, even though we handle all material with care. If materials are sent in, they should be sent return receipt requested or via a courier service such as Federal Express. All material should be properly insured, with a pre-paid sturdy envelope. Be sure the contents are well protected. We open all our mail to check that all material listed on your transmittal memo or query has arrived intact. If it has survived the journey through the mail, and if it's interesting enough, it will be routed to our editors.

Sometimes we do get an unsolicited group of beautiful photos that we'll use. The key to making direct, unsolicited submissions like this work is to think of the use of the pictures from an editorial point of view. Try to hang your picture around a current, newsworthy subject that fits *Animals'* editorial focus. Freelancers should know, however, that unsolicited submissions are really a long shot.

The best way a freelancer can work with us directly is to query first with a sample of his or her work. Appropriate samples include tear sheets, prints, or duplicates, but never originals. We can get an idea of the quality from a clearly labeled duplicate or from printed samples. Photographers should also specify where else the pictures have been used.

The way we usually obtain photos is through Ten Eyck Picture Research in Altamont, New York. They are unique natural-history photo research specialists who work with us routinely on the magazine and other projects. The agency maintains a database of freelance photographs and faxes out our requests.

I recommend that freelancers get their work listed with the appropriate agencies and resources. Our second biggest tool is the Green Book (A.G. Editions, NY). It lists natural history photographers by both photographer and by subject matter. We have also listed our magazine and calendar in *The Guilfoyle Report* newsletter. Sometimes we list our needs with on-line computer services.

We look for extremely crisp photographs that not only depict animals clearly, but also have a strong graphic sense to them. We know that animals can be difficult subjects, but we like to see that a photographer has taken care to produce a good animal photo. Quality, sharpness, composition, and color are all very important. On our covers, we like eye contact, in a portrait style. These are difficult shots to get but they are what we need. All cover shots need to be related to an inside feature story.

Believe it or not, it's sometimes more difficult to find sophisticated photos of more common animals such as cats and dogs than pictures of endangered or exotic species. We want natural looking pictures of cats in indoor settings and dogs in outdoor settings, all wearing collars, and behaving as cats and dogs would behave. No overly cute pet pictures are desired.

Photographers should be aware that we may hold their work for evaluation for at least a month, sometimes two. In making magazine selections, our standard procedure is to go through the first round of edits in a few weeks and then return the non-selects. In the next few weeks we get to the layout stage and, once again, the non-selects are returned.

—Interview by Lisa B. Martin

CHAPTER NINE
Photographic Art and Non-Print Markets

Photographic Artwork

Prices and Terms

Breaking In

Television

Teaching

This picture was printed from a glass plate negative I bought in an antique store, framed, and hung in my gallery. It is titled: "Clam Tucker - on the 'Squam, circa 1900." It has sold over 100 times, in small and large sizes, grossing several thousand dollars (so far). The freelance photographer should investigate all markets, not just the obvious and traditional ones.

Photographic Artwork

The Market

Your pictures have markets other than communicating a message on the printed page. Photographs are, in themselves, considered artwork. They are collected by governments, corporations, small businesses, museums, and individuals. Recent auctions in New York and around the world have seen dramatic increases in the prices collectors and museums are willing to pay for photographs. The reasons for photography's rapid appreciation are many: General confidence in the photography market as a firmly established art form, aggressive acquisition by major museums and foreign investors, and an educated generation of buyers are most often cited by experts in the field.

Photos are also used for purely decorative functions—as photo decor—and installed in buildings' lobbies, hallways, cafeterias, conference rooms, and offices. Large office buildings, airports, and other public buildings must break up the monotony of empty wall space with artwork. And publicly funded buildings in some states are required by law to include artwork.

Picture Needs: The Image

It is difficult to predict what an individual or corporate client will choose to hang on the wall. Asking, observing, and researching in your locale is necessary to determine buying taste, and what galleries, graphics shops, and museums sell repeatedly. Look at posters, post cards, "coffee table" books, and motifs painted frequently by area artists.

Whether your location is mountainous, prairie, seacoast, or urban, look for the scenes and symbols that define the character of the land. Choose a vantage point for an uncluttered, graphic view. Wait for the time of day with the most dramatic lighting, which is usually sunrise or sunset. When photographing closer than the distant landscape, look for timeless and universal statements: clothes on the line, rockers on the porch, or a boat pulled up on a bank. With people, it is usually best to show them as a silhouette, in the distance, or in some other non-specific manner.

The statement of the photographer is also a factor in photographic artwork. Shoot and display what you feel strongly about. Think about what excites you visually—would you hang it in your house? Truthfully, it takes time and life's experience to learn what to shoot and how to approach it. To better define your vision, achieve some depth, and perhaps stumble on some inspiration, read and study art and photo history.

Picture Needs: The Presentation

Buyers in the art market usually prefer view and purchase their photographs matted, framed, and ready to hang. For purposes of economy and efficiency, the photographer should standardize mat and frame colors, and offer a limited number of sizes.

Photo art is both a black & white and a color market. The subject and its treatment by the photographer should be the determining factor. Sunsets, for example, are color subjects, and textures on the side of a barn may photograph better in black and white. I have heard the comment, "oh, don't you just love black and white!" as often as: "look at those colors!" These are the common processes and materials used for framed photographic prints:

Black and white: Shoot with a tripod for sharpness. Use 35mm for a documentary or grainy look. Use fine grain film or larger format for maximum detail, especially in landscapes.

Print on double weight fiber base glossy paper (I prefer Ilford Multigrade), rather than resin coated paper. Follow the manufacturer's recommendations for archival processing. Air dry on clean fiberglass screens, face down. Flatten the prints under weight or in a press for one or two days. Spot out the dust carefully.

Color: If you shoot for publication (except for newspapers, which use color negatives for reproduction), most of your work will be on transparency film (also called slides, when 35mm film is used). As with black and white, the larger the film size, the more sharpness and detail, especially in enlargements greater than 11x14 inches. Also, color rendition is improved with large format films.

Transparency film can be printed directly onto positive printing papers, also called a reversal or "R" prints. Ilford Cibachrome is a popular and readily available color paper, noted for its bold colors and extremely high gloss. The advantage of the sharpness of printing from the original is balanced by the disadvantage of tying up the original for future printing.

"C" prints, which are made from color negatives, can be made from a transparency by means of a color "internegative." Internegatives free your transparency for publication, and offer a greater degree of contrast and color control. The biggest problem with prints from internegatives is lack of sharpness. Use a top-notch professional lab and have them make the internegative 4x5 inches or larger. Insist that it be as sharp as the original. I use the following system with my lab:

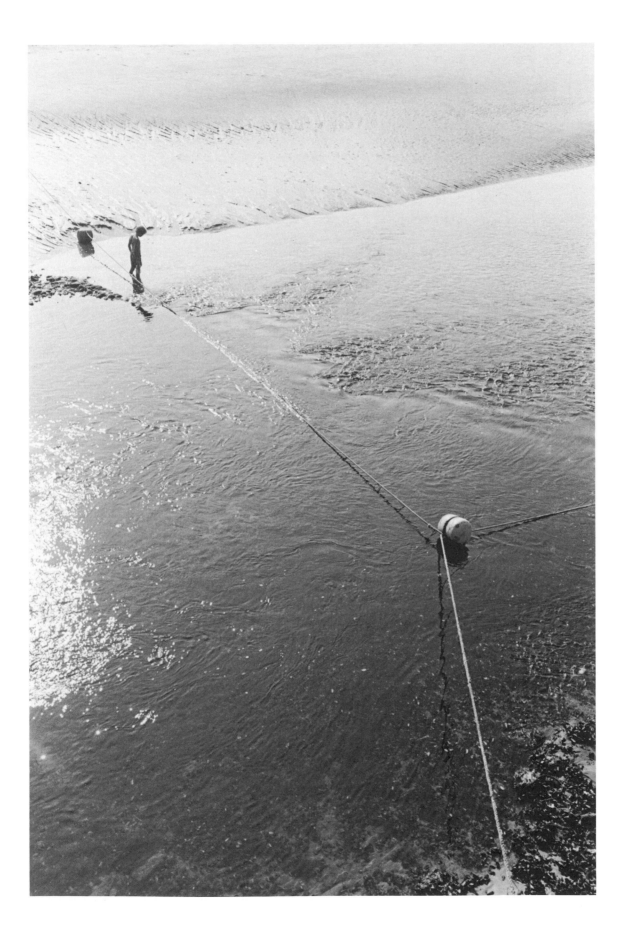

• Convert the transparency (35mm, 2 1/4x2 3/4, 4x5, or 8x10 inches) to an 8x10 inch internegative.
• Inspect and approve one test print, which is usually made to match the color in the transparency.
• Order a number of prints at one time to take greatest advantage of the lab's quantity discounts (I save 80% by having 11 prints made at once).
• The lab keeps the internegative and approved guide print on file for future orders.

Quality and tasteful matting of black & white and color will produce a more saleable product. Use acid-free mat board and foam backing. Avoid loudly colored mats—neutral mat colors will have a broader appeal and let the photograph speak for itself. Whether the print is to be dry mounted or hinged to the mat, use archival materials. The title and signature on the mat should be in pencil or permanent ink. To save money, cut your own mats and do your own framing.

Frames protect the photograph and provide a means of hanging it. As with mats, select a frame that does not distract from the photograph. Silver metal section frames are inexpensive, easy to assemble, and look good on black & white and color prints. Frames and glass can be ordered in quantity at substantial discounts. It pays to standardize.

Breaking In: Corporate Clients

To sell photo decor directly to a corporate client, you need to prepare a sample book or portfolio of color prints and transparencies. Concentrate on bold, dramatic images and on your client's local area. Be ready to quote prices for different sizes of prints.

The person to see when you are selling corporate decoration is usually the public relations officer. At a small business, you'll want to deal directly with the owner. Here are a few suggestions for local clients:

Architects
Banks
Chambers of Commerce
Dentists' waiting rooms
Doctors' waiting rooms
Government offices
Hair salons
Hospital lobbies
Insurance firms
Law firms
Libraries
Motels
Movie theaters
Public transportation
Restaurants

Matching the growth of the art decor market has been that of artwork consulting companies. These firms propose and supply or lease art decor on a large scale. The freelance photographer may choose to be represented by an artwork consulting company. You'll save a lot of legwork and have access to the consultant's expertise, but be prepared to give your agent a piece of the pie!

Find these companies listed in the Yellow Pages under "Art Dealers and Galleries," "Artist's Agents," "Artist's Representatives," and "Interior Decorators and Designers." The best way to find out if an organization uses photo decor and what kind is to call and ask. If you have what it sells, tailor your portfolio accordingly for the interview. I suggest that you bring a lot of color slides and half-a-dozen quality color prints. You must convince your representative that your work is beautiful when blown up.

When you find a firm to represent you, it will select marketable slides to be printed and duplicated for a sample book. The sample book, along with design ideas, is the sales tool of the artwork consulting company. It will continually be shown around to clients, while you're out taking more pictures. When a sale is made, you'll be contacted to make a certain sized print from the original transparency or internegative.

Breaking In: Galleries and Consumers

While photographers may sell a few prints off the walls of their homes and offices, the best way to reach the consumer photo market is through a gallery. Galleries have the major advantage of being open to the public for shopping. In addition, they are designed for display, promote themselves and the artists, and concentrate on being a store to buy art.

Do your research before approaching a gallery. Find out what they sell, and for how much. Are their photographs by nationally known photographers, living or deceased? What is the style and subject matter? Is it in color or black & white? Visit the gallery with a portfolio of matted prints. Seek their comments and advice.

Galleries will usually not buy your photographs for resale, unless you have a track record in fine art photography. They prefer to exhibit your work on consignment, and take a 30 to 50 percent commission when a

sale is made. Some galleries may charge for the hanging space occupied by your pictures instead of charging a commission. Having a gallery represent and promote you is an inexpensive way to test market your photographs and learn how the business works. The most advantageous situation is one in which the gallery owner offers you guidance, moral support, and sales.

Opening your own gallery and selling your own photography has been the dream of many photographers. It carries with it artistic prestige, independence, and no commissions to pay out. You can display much more work than a gallery owner is apt to give you, highlighting the work you feel strongly about. By trying out a variety of images on the sales floor, observing first-hand what people like (and buy!), you'll learn about running a photo gallery quickly. Unfortunately, the lesson may be a costly one.

As a gallery owner, you must select a good location, visible storefront, and convert the interior. Not only do the walls and floors need to be finished attractively, but you may need to cover windows, take down walls, and install track lighting. Next, you'll need a sign, stationery, telephone, furnishings, and possibly a security system. Add to this a business checking account, credit card dealerships, and insurance. And we haven't even printed or framed any inventory yet. Just preparing a gallery for business can be expensive.

Once the gallery is on-line and running, your two biggest expenses are rent/mortgage and staffing. In order to sell pictures, the gallery must be open regular hours. Except for distinctly seasonal areas, this includes weekdays, weekends, holidays, and some evenings. Hiring a full-time salesperson puts a strain on the entrepreneurial budget, and managing all day-to-day operations yourself could prevent you from doing other income-producing work. To avoid becoming part of the list of small business failures, consider some of these common sense measures:

- Fund your business with more money than you think you'll need.
- Plan for at least two or three years to get the gallery going. Up to 60% of your future business will be repeat sales.
- Start small. You can always move to larger quarters later, and you can gradually increase your inventory.
- Join a cooperative gallery, or a joint venture, where the artists share rent, utilities, and staffing.
- Make use of free publicity, such as magazine and newspaper features about you and your photographs. Offer to take or supply free photographs for articles which promote your business.
- Plan and publicize special events, such as openings, holiday receptions, guest exhibitors and speakers, and slide shows to get people into the gallery.
- Display and sell at fairs, festivals, and fund-raisers to reach people who would otherwise not come to your gallery.
- Be objective and business-like without trashing your standards. Every photograph that occupies space and doesn't sell is costing you money.
- Pay attention to buying trends.
- Experiment with new products, but be conservative.
- Regional and mood photographs may have the greatest chance of selling.

Prices and Terms

Prices paid for photographs as art and decor range to the extreme. A gift shop might sell a matted color print for $15, and a 1929 print by Man Ray brought $121,000 at a Southeby's auction. You'll find that many factors, including the photographer's reputation, the gallery's location, the quality and uniqueness of the image, and the presentation, all have bearing on the price.

Artwork consulting companies have first-hand knowledge of what corporate clients are willing to pay in their market area, and size is often used as a pricing scale. Pricing for the individual collector is more difficult. Tastefully framed photographs hung in a well-lit gallery will command higher price tags than the same product at a flea market. A salable and more valuable photograph evokes a feeling, captures a mood, or uniquely communicates a universal situation. Anyone can shoot a sunset. You must shoot it better, differently, and with impact if you want to sell it.

There has been much discussion on the subject of "open" versus "limited" edition photographs. An open edition is when the photographer places no restriction on the number of prints made from a negative or transparency. In theory, open editions devalue and make photographs less collectible, almost like the government printing too much money. In practice, only avidly collected photographers need to be concerned with controlling the numbers of prints they put on the market. Some feel that photography, as a medium of and for the common man, should not be limited and priced for the wealthy alone.

Limited edition photographs are issued in finite quantity, clearly stated on the mat face. 1/50 means that this is the first print out of an edition of fifty. After fifty are sold, the photographer promises not to print any more. Some purists go so far as to destroy the original negative or transparency at the end of an edition. The reason for limiting an edition is to give a higher perceived value to the photograph, and to protect the collector. How limited should an edition be? Experts claim that thirty to fifty prints is a meaningful edition. Unless you're a sought-after fine art photographer, the individual buyer won't be looking for investment value, but rather for artwork to live with and enjoy.

Display rights to the print are what you sell to a client. The photograph may not be reproduced in any way without your permission. When pricing, keep in mind your costs and what you feel people in your area will pay for your images. Following is a very rough pricing guide for photographers who are just getting into the photo art and decor market (applies to black & white and color):

Image Size	Frame Size	Price
5x7	9x10	$75
8x10	11x14	$100
11x14	16x20	$150
16x20	22x28	$200

Organization

When your images exist in the form of color transparencies, duplicate transparencies, internegatives, and color prints, organization is important. Originals, dupes, and internegs are kept in separate files. When an enlargement is needed for framing, or a duplicate for an art consultant's sample book, I need to locate these items quickly. At the same time, I don't want to confuse duplicates with original transparencies, or internegatives with original color negatives. Letter coding seems to be the answer.

In addition to your copyright stamp (© Fredrik D. Bodin), get a seven letter rotating stamp. It's useful for captioning slides (WASH DC) and correlating the original piece of film with it's derived forms. Here is my system for color:

1. First letter of code identifies the form of the image: O (Original), D (Duplicate), I (Internegative), P (Print), or X (Photocopy).

2. Leave a space after the first letter by gently separating it from the other letters. Six letters are left for correlation. Start with "A" as your second letter, which identifies the image. After you've worked your way through "Z," start using two letter combinations as your second and third correlating letters. Remember that the correlating letters are always preceded by a letter identifying the "form" of the image. When you've used up all six letter combinations (at ZZZZZZ), you've correlated over 300,000,000 originals to as many as twenty five different forms.

3. Put original transparencies, negatives, and internegatives into a photo decor master file, in order of stamping.

4. Maintain a photo decor logbook about who has what. For example, "D AL through D BE: City Arts Management, Date," means that you delivered duplicates of AL through BE to that client on a certain date.

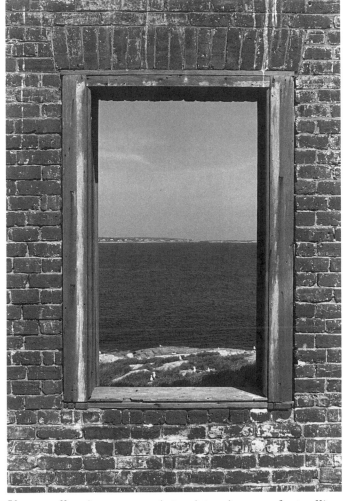

If your gallery is near a scenic tourist region, your best-selling photographs will probably be of that area. Visitors and former residents will buy pictures of local interest as decorative mementos, as will current residents and nearby businesses. The photo of the brick wall and window was taken inside a lighthouse, and looks out to Rockport (MA), a highly touristed area. It is a good seller because it is a strong, local picture.

Audiovisual

The Market

The audiovisual (AV) market has established itself as a specialty market for freelance photographers. Photographs used in AV productions appear in film strips (60-80 frames), slide sets (20-80 slides), videos, and video disks. While selling single images to fill gaps in a production may resemble textbook or magazine work, freelancers serious about the AV market must offer more. Be prepared to offer complete packages, including the pictures, audio script, and sometimes even instructional text. If you think this implies a deep knowledge of the AV subject—you're right. In many ways, AV is closer to the film business than editorial photography.

Audiovisual materials are published for all educational levels. Filmstrips, because of the small investment in projection equipment, are still the most common media in the classroom. The same material may be transferred to video and/or disk for school systems with deeper pockets. AVs are offered as stand alone programs to round out existing curriculums, and also as satellite material to accompany textbooks.

Educational AV producers range in size from small one or two person shops to large companies with several hundred shows in their catalog. To find local AV firms, look in the Yellow Pages under "Audio Visual Production Services," and "Slides and Film Strips." It's also worth checking with textbook publishers about AV needs. To see what's being used and who's producing it for schools, visit the AV or media specialist in a school.

The effectiveness of audiovisuals has been no secret to industry. Businesses use AV for employee training, sales, recruitment (employee or student), and informing the staff and public about a new product. Although larger companies may maintain AV production capabilities, these departments are the first to fall victim to financial cutbacks, or may be understaffed and in need of freelance help. In addition to the companies themselves, industrial AV producers can be found in the Yellow Pages under the educational categories above and under "Motion Picture Producers and Studios" and "Television Films - Producers and Distributors." Public relations firms may also supply AVs to their clients.

Picture Needs

AV is a color market. Shoot transparencies, preferably on Kodak Ektachrome or Fuji Fujichrome film. These films are favored for ease of duplication (Kodachrome is "contrasty" to start with and picks up additional contrast during duplication). Always use the same film and emulsion for one job to insure consistency of color. If daylight or strobe lighting permits, use a film speed of ASA/ISO 100 or less for finer grain and richer colors.

A horizontal 35mm format is standard for AV. Verticals are suitable only for slide sets or, for lack of another image, if they can be cropped to a horizontal. Photographs intended for videotape or videodisk programs must crop to the nearly square video screen format.

Most educational subjects are covered by audiovisual programs. In addition, current topics are explored in-depth, such as ecology, recycling, and toxic waste. For a more complete listing of the kinds of pictures used in educational publishing, see Chapter 7.

AV has multiple uses in business, government, and industry. The subject matter is diverse, but the intent is consistent—all AV educates someone about something. Here are some uses of audiovisual presentations in the business world:

• Annual meetings
• College orientation
• College and private school recruitment
• Corporate community relations
• Customer education
• Documentation of funded projects
• Employee orientation
• Employee training
• Government information
• Product applications—at conventions and in stores
• Proposals for contracts and grants
• Sales personnel motivation
• Sales presentations
• Tourist information

Bohdan Hrynewych

Bohdan Hrynewych

Freelance photographer Bohdan Hrynewych shot a television production studio as part of a cable company's AV show, and informal street portraits for an insurance firm's sales presentation.

Breaking In

The Audiovisual Portfolio

Audiovisuals speak a different language than print media. They face different audiences and must solve different problems. A print media portfolio alone is not enough for selling yourself as an AV photographer. For an effective presentation, incorporate the following elements into your tailored AV portfolio.

1. Arrange to show your portfolio by projection. Bring it in a slide tray.
2. Show fifty to eighty slides, only color.
3. Open presentation with a title slide, such as "An Audiovisual Portfolio by Fredrik D. Bodin."
4. Consider using title slides to introduce sections of your portfolio: "People at Work," "Industrial Architecture."
5. Use strong, nonbusy pictures. They need to come through in three to four seconds.
6. Show almost all horizontals. Show that you can photograph a vertical subject horizontally. AV people use horizontals and are plagued by verticals.
7. Have in-depth or sequence coverage of something.
8. Highlight your location lighting skills.
9. Bring your print media portfolio for conversation after your main presentation.

It is to your advantage to slant your AV portfolio to the type of production the AV firm does, be it educational or corporate training. If you are approaching a corporate client directly, contact the media or public information department for a portfolio review. At smaller companies, you'll probably be dealing with the boss directly. It is certainly appropriate to suggest AV projects to your potential client, but be prepared to support your ideas with how they'll benefit the company.

A busy AV client will forget you unless he or she is periodically reminded that you're still interested. Be sure to leave a business card and, even better, a stock list. A small horizontal printed piece sent to your client every few months will prevent him or her from forgetting you.

Prices and Terms

AV producers are not known for their generosity to photographers. Rates vary among AV firms and the budget of each production impacts how much can be spent on photography. Some production houses, seeking to keep their costs to a minimum, offer relatively low pay and demand all rights to the photographs. If you agree to this kind of "buy out," expect to see your photos not only in a slide show, but also in advertisements and brochures—with no further payment to you.

Because there are no pay standards, expect to be offered $20 to $125 for single images. Rare photos may earn more, and clients will expect substantial discounts when buying in quantity. Assignment rates can vary from $150 to $500 per day, plus expenses. An AV day can be longer than eight hours, so be flexible. Whatever rate you negotiate should apply to a one-time show, shows over a one year period, or a specific production run of filmstrips of other media.

Some AV firms ask photographers to bid on an entire job. If you're not experienced in this field, there is a serious risk of underbidding. AV production costs have a way of getting out of hand. It's much safer to work by the day and let the client control the costs. If you should venture a quote on a job, remember this rule of thumb: An AV client pays about $1,000 for each minute of showing time.

In addition to selling single images and shooting by the day, some successful AV photographers offer packages, complete with text and photographs, to educational AV publishers. Teachers familiar with curriculum needs are sources of ideas for AV's, and are in a position to script and shoot their own. Payment for 80 slide packages can be a flat fee of $500 to $1,500. AV author/photographers may also negotiate royalties and advances with their publisher. The average royalty is 10 to 15 percent of gross sales. If you've signed on with a publisher with good distribution, you stand to make substantially more from royalties than a flat fee.

What should a freelancer do when confronted with an AV client who wants all rights? Negotiate until your client agrees to buy nonexclusive rights. Assure your client that you won't sell the show as a unit, or that the pictures won't be sold for another AV use. Then the firm doesn't have to worry about a competitor getting the whole show. In view of the small payment freelancers get for AV work, they've got a strong case for selling their slides to other markets.

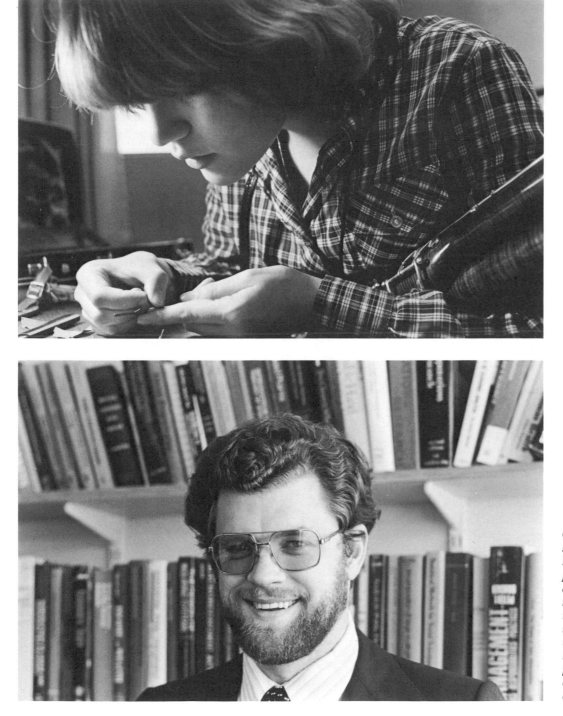

College and private school recruitment relies heavily on AV presentations. Some less obvious subjects for a recruitment slide show might include student work (especially in the visual arts), dormitory living, close portraits of faculty and students, and successfully employed graduates.

Television

The Market

Television, if you can believe it, is a healthy market for your photographs. We associate TV with motion and sound, overlooking the many uses of still photos on the screen:

Station Identification: A background photo is used behind the station call letters.

Program Promotion: Photo of talent (actor) or action used to promote program.

Program Opener: Photo or series of photos used to introduce a program, usually in conjunction with a title.

News Background: Using rear projection or chromakey, a general background photo remains behind newscaster during broadcast. May be replaced by specific news story picture.

News Chroma: A boxed-in photo relevant to news item appears next to newscaster.

Weather Background: Season photograph is shown behind weather reporter and/or written forecast.

Picture Needs

On-screen picture needs are exclusively color, unless you have an exciting spot news photo. Background pictures are usually of your local city under various lighting and weather conditions. Each station, however, has its own definitions of good TV graphics.

Color slides or prints may be used for TV graphics. I prefer to shoot slides for their resale value to other markets. Keep in mind that television is horizontal. If you're shooting 35mm and it must fit the TV screen, you'll have to mask your viewfinder.

Off-screen pictures are also a part of television. Portraits of station personnel are hung in the lobby. Local productions need stills for publicity purposes. Head shots are sometimes needed in a hurry for special press credentials.

Breaking In

Researching the local TV market is easy. Start a picture use log for each station. The concentrated still usages occur during the evening news. Investigate a different station every night. Also be aware of still photos and take notes during your regular viewing. You'll soon have enough information to fill out a Photo Market Analysis (Chapter 4) on each channel.

Confirm the fact that a station is using freelance photographers. Stations are listed in the Yellow Pages under "Television Stations and Broadcast Companies." The person in the know is usually called the graphics director, news graphics director or art director.

Prepare your stock portfolio for television. Research relevant color pictures, preferably horizontals. Go beyond what the station is already using—research what you think it should be using. Show at least two slide sheets of color. And don't forget to have your stock photo list ready.

Also tailor your portfolio for TV assignment work. Since most jobs will be shot under TV studio lights, put similar situations in your book: concerts, plays, speakers, and studio portraits. This way, you'll appear competent under conditions similar to TV. Your combined assets of stock and assignment services should put your name at the top of the freelancer's list, which is usually a yard long!

Seasonal station identification photos, such as the one above, are apt to be aired during daytime programming.

Prices and Terms

Like AV, the television market is not accustomed to the rates freelancers command in the print media. Television is a hungry consumer of images, chewing them up and spitting them out. Your TV client may feel that a single image, on the screen for just a few seconds, isn't worth much.

The only defense I've been able to come up with, short of abandoning the TV market, is this: "If television is such a voracious image user, then you wouldn't mind buying a quantity from my collection. It is not feasible for me to sell reproduction rights to one or two photos at your rates. However, if we can agree to a large enough order, some compromise is possible." I want $75 per image, but I'll take less when a few dozen are bought at once. The TV station pays for the duplicate transparency. You should specify the rights you are selling: On-air non-exclusive news graphic television rights are granted for the photographs listed.

Television stations can also hire you by the day for on- or off-air work. They may send you around the city for graphics file photos, thinking they'll get more pictures for their money. Let your client have duplicates from the assignment for TV use. Don't give up your originals! Once you start a policy with a client, it's difficult to change it. And you've devalued a future market for yourself and other freelancers.

A multiethnic television program flashed this portrait in a series of faces for the opening. The viewing time for this photograph was a half-second.

Teaching

The Market

Teaching photography can serve various functions for freelancers. For the fine art photographer, teaching can be a means of survival. For the aspiring freelancer, regular paychecks can stabilize cash flow during slow periods. The high-powered freelance photographer finds teaching a refreshing break from the business roller coaster. Also, the academic arena provides an environment for creative growth.

A photographer with knowledge and patience can teach. Add some inspiration and organization and you've got a great teacher. I enjoy sharing my photographic enthusiasm in the classroom. Teaching benefits me by fostering clear thinking and new ideas. I can put aside my own concerns and help someone else with theirs.

Photography is a popular subject, both for hobbyists and those seeking a career. Educational institutions are eager to cash in on this demand, but not so eager to hire full-time faculty. The answer, and niche for freelancers, is part-time teaching. Just as magazines and book publishers use freelance artists and photographers, schools find it more economical to hire part-time teachers according to enrollment. From the freelancer's point of view, such contract teaching pays more than other non-photographic work and provides the freedom to pursue commercial work. If you can efficiently schedule a few part-time teaching jobs, you'll be making good money—and avoiding the obligations of academic rigmarole.

Summer camps, high schools, and adult education programs are excellent places to begin teaching. They offer basic and intermediate instruction. This is the place to develop curricula, gather teaching materials, and find out if teaching agrees with you. You'll be surprised at the knowledge and skills you have to offer your students.

Colleges and universities offer more opportunities for freelance teachers. If a college has no major program in photography, you may find courses in the art department, school of architecture, or division of continuing education. Colleges that grant degrees in photography are listed in the *College Blue Book* (Macmillan Publishing Company). Macmillan also publishes a *College Blue Book* of "Occupational Education," or technical schools which grant an associate degree. Educational institutions of all kinds are listed in the Yellow Pages under "Schools."

Although photo workshops have seen their heyday, the survivors are still important learning centers, and are bigger than ever. They are found all over the country—in barns, hotels, and restored farmhouses. Workshops seek students on all levels, full-time and part-time. And photo workshops, known for their diversity of courses, hire freelancers to teach their photographic specialty. Look for workshops advertising in the back of photo magazines.

Breaking In

The first question you're bound to ask is, "Do I need a college degree in photography to teach?" Any college degree (not necessarily in photography) will help cinch the job, but part-time teaching does not always require it. The important thing is knowing your stuff and being able to deliver it. For a teaching interview, you'll need a resumé (see Chapter 4) and a portfolio. If you want to teach a specialized subject, such as photojournalism or studio lighting, tailor your portfolio accordingly.

The toughest method of finding teaching work is in the help-wanted pages. The few positions that are advertised are swamped with applicants. Here, you take chances with the rest of the mob.

I've had much better luck creating my own courses for schools. First, research the school catalog to see what is offered. Think about what you could add to the program. Query the appropriate administrator or faculty with your course idea. If the school is interested, design a course for it.

People are buying expensive cameras in record numbers, and they're eager to learn how to use them. Photographic education is growing on all levels to meet the needs of hobbyists, students, and professionals.

Designing a Photography Course

Besides a sound knowledge of your subject, you should also know the length of each class and the number of class meetings. As you design your course, it may become obvious that you need more "meat" for lectures. The only solution is to bolster your course content with research. Students catch on quickly if your lectures are "empty cannons rolling on the deck."

1. List all major topics to be covered in the course.
2. List minor topics to be covered in the course.
3. On index cards, one for each class, assign major and minor topics.
4. Arrange index cards in logical learning order. Number classes in this order.
5. Add other modes of instruction to lectures:
 a. Student research presentations
 b. Written and shooting assignments
 c. Informational hand-outs
 d. In-class equipment and material demonstrations
 e. Audiovisual presentations
 f. Guest lectures
 g. Field trips
6. Type course outline. Define method of evaluation (grading). Hand out to students at first class.

Teaching Ideas

The best course ideas are ones that interest you and about which you already have some knowledge. College catalogs and photo books can suggest ideas. Here are some that may interest you:

Alternative printing processes
Color slide photography
Creative vision
Interpreting photographs
One-day outdoor photo adventures to nearby locations
Photographing artwork
Photographing people
Photography for writers
Self-discovery through photography
Special effects
Weekend lecture at country inn. Shoot by day, lecture by night.

Prices and Terms

Part-time adult education pays from about $12 to $20 per hour of classroom time. Colleges, daytime or evening, pay $15 to $35 per hour. If you are recognized in your field of photography, you may get more. Some colleges have a sliding pay scale adjusted to the number of students enrolled. They may offer you $5 per hour if only six students enroll, and will pay the full salary if the course fills up. Don't be afraid to say "no, thanks" if the pro-rated pay is low.

Weekend workshops pay by the day. Again, your level of professional accomplishment will influence your negotiated fee. I like to charge at least 2/3 of my photographic day rate for teaching. After all, it's a serious job, it's exhausting, and it takes time to do it right. Start by charging $150 per day for teaching. There is no rate ceiling.

Don't forget to have extra expenses written into your agreement: honorariums for guest lecturers, slide duplication, photocopying, and special materials. If you don't make arrangements for expenses before running the course, they'll come out of your pocket.

When negotiating with an educational institution, keep in mind that a school is a commercial enterprise. You can charge more if your course fills the classroom. But, if you can't prove that you'll draw plenty of paying customers, don't expect the school to go into the red for you. If you think your course will be popular, but can't convince the school of this, offer to take a percentage of the "gate" instead of a fee. The economic formula for education is this: The tuition multiplied by the number of students must exceed the instructor's fee and all overhead costs.

CHAPTER TEN
Selling Stock Photographs

The Value of Your Stock

Selling Your Own Stock Photographs

Preparing a Stock List

Consignments

Mailing Photographs

Stock Picture Agencies

Effective Stock Strategies

Any subject that is well-photographed is a potential stock sale. The trick to making money in the stock photography market is knowing what photos are in demand often and what kinds of photos are in short supply.

The Value of Your Stock

The primary source of income for freelance photographers is shooting to fulfill a client's picture needs—assignment photography. There is another valuable resource that all photographers already have, but few take advantage of—stock photography. A stock photograph is one which has been shot for a client, taken by the photographer as a self-assignment, or simply a picture made for pleasure. Although the photo may have served its immediate purpose, its useful life is far from over. A stock photograph can be sold again and again by the photographer and by a stock picture agency.

Don't assume that your stock has no value. As you read on, you'll see that even the most ordinary subjects can be sold as stock. Rarely are photos so specialized that they can't be marketed elsewhere, even to the original client for a reuse fee. If you sell your clients all rights to the pictures you take for them, you're undermining the value of your stock collection. You're giving away money.

I consider the sale of stock photos an important part of my income. Every year, I sell thousands of dollars worth of stock myself, and so does the stock picture agency that carries my work. Most of the pictures that sell are not dramatic prize-winners or taken in exotic places. They include everyday scenes that I've photographed since high school: activities, family, friends, vacations, and all the leftovers from assignments.

Never say that a picture won't sell. I'm always surprised when the most unlikely of my stock photos is sold. For example, I've even found a market for my technical failures and foul-ups: publishers of photographic how-to books need pictures illustrating lens flare, poor exposures, camera movement, and so on. There are buyers for all photographs. You just have to find them.

Stock photographs are a by-product of all your shooting assignments. Your stock equity grows as you shoot more and more, year after year. The beginning freelancer must realize that nobody starts out earning a living just by selling stock photos. It is an auxiliary income source which must be built up over a period of time. The seasoned freelancer, with the extra income and knowledge gained from stock sales, can afford to take the time to shoot selectively for the stock files. Start now by hanging onto your stock by not selling all rights, getting it organized, and learning how to sell it.

Every client I have buys stock. They do this because (1) buying a stock photo is cheaper than hiring a photographer, especially if travel is involved; (2) chang-ing of the seasons limits assignment shooting because many publications are assembled two to four months before printing—seasonal shots must be assigned a year in advance or bought as stock; (3) buying from different stock sources affords the editor a wide variety of choice; (4) a stock photo is a known quantity, and editors feel secure with a good picture in hand as deadlines approach; (5) buying stock is convenient and quickly solves picture problems; (6) a unique one-time event that has already happened cannot be assigned—it must be purchased from stock. After I start shooting assignments for a client, I start developing them as a stock client. This way, clients that I already have can be doubly profitable. Who else has better knowledge of the client's stock picture needs that the photographer who does their regular assignment work?

Stock photographs can also be used as an entree to assignment work. Part of my marketing strategy in approaching potential clients is to lure them with useful stock. The client sees these relevant photos in my tailored portfolio and references them on my stock list. A photographer who has organized and accessible stock photos is more than shooting talent: He or she is a picture resource. This makes the photographer's services twice as valuable to a client, and a cut above the competition.

Best of all, income from stock feels like free money. It's all gravy. You did the work when you took the picture. Now, with a little marketing, the picture works for you again. When it's time to retire and relax, a lifetime of stock photographs will still be producing income.

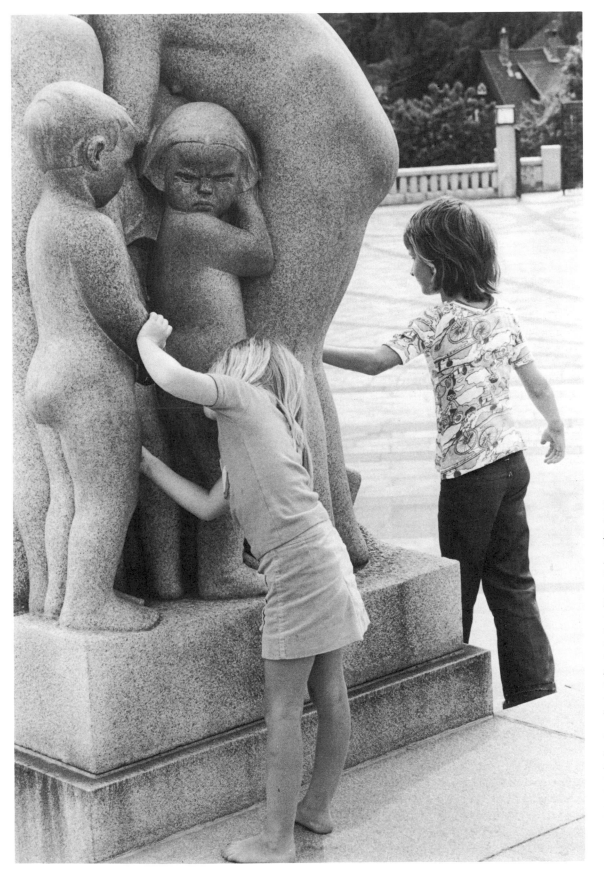

This is still my best-selling stock photograph. Taken in Norway while I was vacationing and shooting for fun, it has been used by hundreds of books on child development, psychology, and sex education. Income generated by this one black and white picture has passed the $20,000 mark, and is still rising. The cost of the original month-long Scandinavian tour: $1,200.

Selling Your Own Stock Photographs

Organizing Your Stock Files

In order to start selling your own stock photographs, you need to know what you've got and be able to locate specific images quickly. The most efficient storage and indexing device is the metal file cabinet with letter-size hanging file folders. Easily expandable as your collection grows, file cabinets also protect your pictures from dust, light, airborne pollutants, and physical damage.

Black and White Prints

Print all of your black and white on glossy resin-coated paper. Most clients asking for black and white stock will prefer to see 8 x 10 inch prints, which fit into the letter-size hanging file folders and into standard 9 x 12 inch mailing envelopes. Each print should be of first-rate technical quality, with dust and scratches carefully spotted out. Your copyright notice (see Chapter 11) and caption should appear on the back of the print. When using stamp pad ink on resin-coated papers, be careful not to let the wet ink smear onto the surface of another print. Either blot the ink or use paper labels.

If your portfolio is designed to use 8 x 10 prints, you can anticipate a client's picture needs and slip stock photos from the files directly into the portfolio pages. It's a great selling advantage and a time saver to have interchangeability made possible by uniform print size.

Color Slides

Cardboard or plastic-mounted 35mm and 2 1/4 x 2 1/4 slides are stamped with your name and copyright notice and put into archival slide sheets. I prefer the side-loading sheets because they prevent the slides from falling out, which happens more frequently with top-loading slide sheets. Each sheet should hold only one subject category. The sheets are then placed in the hanging folder of the appropriate subject category. Don't put color and black and white into the same folders. Start a file drawer for each.

Because of the risk of physical damage, large format transparencies should not be put into the file drawers with 35mm slides. 4 x 5 inch and larger transparencies are kept in the acetate sleeves they come back from the lab in, to which a label with caption and copyright notice is affixed. The sleeved image is then put into an archival plastic page and then put into a boxed three-ring binder (Safe-T-Binder by Vue-All).

Black and White Negatives and Contact Sheets

A system for locating a contact sheet and then finding the negative for a client is essential. This is how I organize my black and white.

1. After processing and drying, cut 35mm negatives into strips of six frames each.
2. Make a contact sheet of the negatives onto 8 1/2 x 11 resin-coated enlarging paper. If your client needs a contact sheet for reference, make an extra one now. This size paper easily accommodates a 36-exposure roll cut into six strips.
3. Before developing the contact sheet, write a reference number on the back of it with a ballpoint pen. I use an ascending date and roll number system, referring to the date the roll was shot and how many rolls I shot that day. 920704-02 is the second roll I shot on July 4, 1992. This number always appears on the back upper right of every contact sheet.
4. Write the same reference number on an archival negative storage envelope or page. I put the entire roll into one 9 x 2 inch polyethylene envelope. The contact sheet and negatives are now identified and linked with the same reference number.
5. Contact sheets are filed chronologically in file folders.
6. Negatives in their envelopes are stored chronologically in a letter-size file cabinet. If you use pages to store negatives, put the pages into a boxed three-ring binder or in regular binders kept in a metal file cabinet. Never store your negatives in an environment with light, extreme heat, or excessive moisture.

Now, any client can call and order a print by referencing the roll and frame number. You can also find specific stock photographs on a contact sheet and quickly pull the negative for printing.

Subjecting Photographs

All black and white prints and color slides are filed by subject. Start with very general and obvious categories that apply to your collection: animals, beaches, cities, nature, people, and work. Look at my stock list for subjecting ideas.

As you continue to shoot, add more subject categories as needed. When any one file becomes too large and becomes burdensome to look through, subdivide it. For example, if the People category outgrows its file folder, subdivide it into People—Infants, People—Preteen, People—Teenagers, People—Middle Aged, and People—Elderly. The point is to invent logical categories so you can locate the right picture for a client easily.

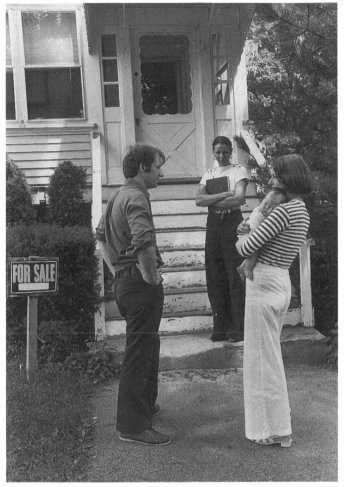

With some knowledge of current stock photo needs, a freelancer can go out and "shoot for the files." I keep a list of hot topics for times when assignment work slows down. Acting on a tip from my stock agency, I recruited some friends who had just had a baby and bought a house. We planted the old "For Sale" sign in the front yard and I had another friend stand in as the woman realtor. I shot one roll of this very simple setup, and made several prints for the agency. For several years now, business and family books have paid thousands of dollars to use this image.

Mailing Photographs

1. Stamp your copyright notice on the back of prints, and on the front of slide mounts. Try to always put the stamp in the same position, for a consistent look.

2. Caption prints and slides, if necessary. Short captions can be written on the front of the slide mount. Indicate model released photos, if any. Put the slides into a clean slide sheet.

3. Fill out the consignment form in duplicate.

4. Insert the photographs and one copy of the consignment into a mailing package. Use either a manila envelope with cardboard taped around the photos, or a stiff cardboard mailer. Cardboard mailers weigh and cost more, but offer excellent protection (see Resources on page 147). Seal the envelope flaps with tape.

5. Write the client's name and address on face of package, stamp your return address in the upper left corner, and write or stamp: Photos—Do Not Bend."

6. Use the appropriate delivery method. (a) U.S. Postal Service first class mail: Use only for mailing contact sheets or a small number of black and white prints to a known client. (b) U.S. Postal Service certified mail with return receipt, United Parcel Service with Acknowledgement of Delivery, or Federal Express: Use when mailing transparencies, negatives, or a sizable quantity of black and white prints. Each carrier obtains the recipient's signature, proving that the package was actually delivered. With the exception of Federal Express, which keeps the recipient's signature in the driver's log, you are mailed the signature card. Staple this card to your copy of the consignment.

Tip: If your client insists on overnight delivery, ask for their Federal Express or other overnight carrier account number, so that delivery charges are billed to their company. Keep this number on file with your client's address and phone number in case they request rush delivery again.

Preparing a Stock List

Every freelance photographer should be selling stock photographs, and every freelancer should have a stock list. The purpose of a stock list is to give picture buyers a directory of what you've got in your files. Your stock list gets scrutinized, searched, posted, and kept as a picture resource. Also, it is something for the client to hang on to, and helps them remember you. And it shows that you're organized and seriously in the business.

When you're getting started, a general stock list will be sufficient for most clients. Later, if your photo coverage becomes concentrated in one area, a more focused list for a targeted market will be in order. The subjects listed on a general stock list are an expanded version of your picture file categories. Knowing the needs of your market will suggest ways of listing and cross-referencing photographs. For example, suppose you have coverage of high school students working at computers. Recognizing what the educational textbook market looks for (see Chapter 7), you should list those pictures on your stock list under "Computers," "Education," "High School," "People," "Students," "Teens," and "Youth." This way, the picture researcher is more likely to find the photo category on the list, call you, and buy the photograph. Your stock list should be sent out to every contact you've made in the past. This is a great opportunity to renew business relationships by adding a short note on what's new and what you're doing now. All outgoing mail such as consignments, invoices, and other correspondence should also contain your stock list. You'll be amazed at how many clients retain these documents. Finally, when seeking new clients by interviewing or by mail, make sure you leave them a stock list.

A word of warning—don't misrepresent what you have in stock. There is a temptation to list categories where you have very few or very weak images. A circulating stock list is certain to generate phone calls and picture requests. Don't alienate potential clients by stretching the truth.

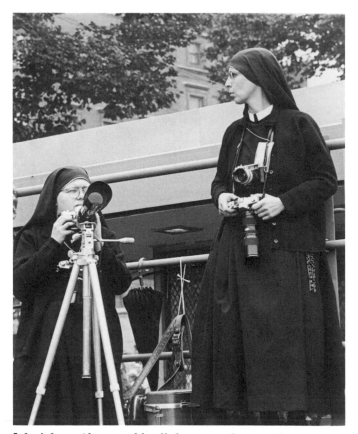

I don't know if you could call these two photographers freelancers, but they definitely mean business in gathering stock photos of Pope John Paul II.

evident as you shoot and need to insert new additions into your stock list.

To achieve a professional look, use a high quality typewriter or laser printer, so that the letters have sharp definition. Have a print shop make five hundred offset or quality photocopies (about $25). Local "quick" print and copy shops can give you personalized service, rapid turnaround, and a rock-bottom price.

Logistics: Stock List

Keep your general stock list on one page, so that it doesn't look like a chore to read. On a blank sheet of basic stationery or computer-generated letterhead (see Chapter 12), type your stock list alphabetically in columns. You may use my sample stock list for category ideas. If the list is too long, delete the weaker entries and/or use a smaller typeface. The advantages of using a computer to prepare your stock list will become

Stock Photographs

Accounting	Factories	Massachusetts	San Francisco
Agriculture	Fairs	Measurement	Santa Fe
Animals	Fall	Medieval Program	Sand Castles
Apple Computers	Family	Metric	Scientists
Architecture	Farms	Mexico	Sculpture
Arizona	Fireworks	Minorities	Sewage Treatment
Artists	Fishing	Mississippi	Sex Roles
Automotive	Fjords	Mobile Homes	Ships
Bahamas	Florida	Montreal	Shopping
Balloons	Food	Moods	Signs
Beaches	Forests	Motorcycles	Skiing
Belgium	France	Mountains	Snow
Bicycling	Friends	Musicians	Software
Birds	Gardening	New England	Sports
Blizzards	Germany	New Hampshire	Spring
Boston	Glaciers	New Mexico	Statue of Liberty
Bridges	Grand Canyon	New York City	Suburbs
Businesses	Grandparents	New York State	Subways
Camping	Hang Gliding	North Carolina	Summer
Canada	Harbors	Norway	Sweden
Children	Health Care	Nova Scotia	Synthetic Blood
Children's Museum	High Technology	Nuclear Energy	Teens
Christmas	Highways	Oceans	Tennessee
Cities	Hiking	Parenting	Texas
Civics	Homes	Paris	Tourism
Cleveland	Horses	Parks	Towns
Clouds	Hospitals	Patterns	Traffic
Colleges	IBM Computers	People	Trains
Colombia, SA	Ice Cream	Pets	Transportation
Colorado	Industry	Plants	Trees
Computers	Inns	Photographic Effects	Urban Renewal
Connecticut	Insects	Photographers	US Virgin Islands
Construction	Irrigation	Police	Utah
Cosumel	Kayaking	Pollution	Vermont
Consumers	Lakes	Portraits	Washington, DC
Couples	Landscapes	Power Plants	Weddings
Crowds	Las Vegas	Rain	Wind Power
Denmark	Leisure	Real Estate	Winter
Dumps	Lighthouses	Recreation	Women
Earth Science	Litter	Recycling	Work
Eating	Logging	Religion	Zoos
Ecology	Louisiana	Restaurants	
Education	Maine	Rivers	
Energy	Malls	Rhode Island	
Erosion	Maple Sugaring	Rowing	
Everglades	Marathons	Sailing	

Fredrik D. Bodin • 5 Wiley Street • Gloucester • MA • 01930 • (508) 281-3771

Consignments

Why Consignments Are Necessary

Many photographers are nervous about sending out photographs, especially to people they've never met. There are worries about loss, damage, and failure to return the pictures. The solution to these concerns is called a "consignment." A consignment is a packing list that is sent out with every shipment of photographs. Stock agencies use them to send out pictures by the thousand. Freelancers can send out photographs securely too, by following the same business protocol and consignment procedures. Remember that a photo languishing in your files has no chance of selling.

Freelancers should never send out unsolicited photographs. Always contact the recipient first, preferably by phone, to make sure that he or she is expecting your shipment. Photo buyers hate to be burdened with returning photos they never requested. The preshipment phone call is not only good business manners, but it can reveal an altered deadline, a previously filled picture need, a canceled project, a new mailing address, or even some last minute picture requests. Also, speaking with your client personally makes you a human being, rather than a package of photographs, and thus more likely to get work.

What Consignments Do

A picture buyer who is anticipating your shipment of photos will expect to find a consignment. On the consignment form, they will find an account of what and how many pictures were sent. The photographer also keeps a copy of the consignment. Now it's very clear to both parties who has what.

Consignments also spell out the terms under which the photos are submitted: What happens if one is lost? Are there model releases (signed permission to use the picture)? How should the pictures be returned, and when? In the presence of a consignment, your client will hold a more professional opinion of you and treat your photos more carefully.

Stock Photograph Cycle

1. Organize photos into subject categories, and put them into subjected hanging file folders.
2. Inventory the photos and create a stock list.
3. Identify clients who may need the kinds of photographs you have in stock.
4. Research the clients you intend to approach by reading their publications, writing for photo guidelines, and checking reference sources such as the *Photographer's Market*.
5. Find out the client's immediate and continuing photo needs.
6. Inform the client of the contents of your stock files verbally, by showing samples, and by giving them your stock list.
7. Request for stock photos is made by client.
8. Research of client's request is done by photographer in the stock photo files.
9. Consignment form detailing photos being submitted is filled out in duplicate by the photographer. The photographer's copy is filed under "Active Consignments."
10. Package containing the photographs and consignment is mailed or hand delivered to the client.
11. Review of submission is made by client.
12. (a) Entire consignment is returned to the photographer by the client, with regrets. Photographer updates the consignment form, noting date and contents of returned package. If all of the photos have actually been returned and no damage is evident, the consignment is filed under "Canceled Consignments." (b) When a partial return of the consignment is made, with some images being held for further consideration or publication, the photographer must again update the consignment form. Note the date, what was returned, and what is still being held. Attach any correspondence from the client. Since some photos are still being held, refile under "Active Consignments."
13. Publication rights are requested by the client.
14. The photographer sends an invoice to the client.
15. After publication, the photos are returned to the photographer. The consignment is once again updated, and the images are put back into the stock files.

Finding Stock Clients

Once you've got your stock collection organized and feel you have something to sell, you'll need to target appropriate markets. Whom you approach depends on the content of your files and the picture needs of the client. Here are some ideas to get you started:
- Evaluate your current clients' stock needs.
- See which local markets use or may potentially use stock photos (see Chapter 2). Make yourself known as a stock resource and give them your stock list.
- Look in the Yellow Pages under Advertising Agencies & Counselors; Graphic Designers; Public Relations Counselors; Publishers, Book; Publishers, Directory & Guide; Publishers, Periodical; Television Stations.
- Study the *Photographer's Market*.
- Request samples, investigate, and subscribe to one of the stock and marketing newsletters published by PSI International, Osceola, WI 54020.
- Request samples, investigate, and subscribe to *The Guilfoyle Report* (see "References for the Freelancer").

CONSIGNMENT

Client Name: Project:
 Company:
 Street:
 City: State: Zip:

Request Date: Consignment #:
 Due Date:
 Ship Date: Ship Via:

Description	Image Size	B/W or 4/C	Quantity

Total Returned: Total B/W:
Date Returned: Total 4/C:

 Total Photos:

TERMS OF DELIVERY AND USAGE

RIGHTS: This consignment does not offer reproduction or other rights. PAYMENT: Rights to use any photograph are tendered by invoice and are granted only by payment of that invoice. RETURN: All photographs must be returned as soon as possible, or upon demand. 4/C (color transparencies) must be returned by verifiable delivery. HOLDING FEE: After 30 days, a holding fee of $1.00 per day per image will be charged. LOSS OR DAMAGE: Recipient is responsible for loss or damage to these photographs until actually delivered to Fredrik D. Bodin. Damage must be reported within 5 days of receipt, otherwise shipment is assumed intact. In the event of loss or damage, recipient agrees that the value of of each color transparency shall be $1,500 unless indicated otherwise next to said item above, and the value of each B/W (black and white print) shall be $35. MODEL RELEASES: No model releases exist on any photo unless specified in writing on this consignment or invoice. Where the existence of such release has not been specified, user shall indemnify Fredrik D. Bodin against all claims arising from the use of said photograph. In any event, the limit of liability of Fredrik D. Bodin shall be the invoice price of the photograph.

Fredrik D. Bodin • 5 Wiley Street • Gloucester • MA • 01930 • (508) 281-3771

Stock Picture Agencies

The Market

A stock picture agency files and sends out stock photographs to potential clients. The photos are supplied to the agency by freelance photographers. When a sale is made, the stock agency pays the photographer a commission or royalty, which is usually 50 percent of the selling price. One-time reproduction rights are sold, and after the photo has been published, it is returned to the agency's files to be sold again. The photographer retains ownership of the photos, may recall them, and may continue to sell stock out of his or her office.

The advantage of belonging to a stock agency is that it leverages the earning power of your photos with minimal effort on your part. The agency serves as a central resource for publishers around the world. They are continually striving to make new contacts, promote their business (and your pictures), and hone in on the market's needs. The stock agency's staff is working 40 hours a week to sell your work. All this is done with photographs you've already taken.

Realistically speaking, few photographers make their living from stock agency sales alone. Freelancers must pursue shooting careers for a variety of clients, and continually channel the resulting photographs into the stock agency. Only over a period of years, with thousands of images on file, will the freelancer begin to see substantial returns from the stock agency. Stock is a numbers game—the more photos you contribute to the agency— the more money you'll make.

The responsibility of the stock agency is to (1) establish and maintain photo files and office space necessary for the transaction of the stock photo business; (2) employ photo research, accounting, and other supporting personnel; (3) garner and serve clients efficiently; (4) recruit and represent photographers whose work exhibits sales potential; (5) make as much money as possible for themselves and contributing photographers. Some stock agencies also give assignments. The photographer's responsibility, besides cashing the checks, is to (1) supply the stock agency with high-quality black and white prints and color transparencies (usually selected by the agency); (2) allow the photographs to remain with the agency for a reasonable amount of time (specified in the contract); and (3) contribute new photos to the stock agency's files regularly.

Picture Needs

Stock picture agencies differ in the markets they serve, and therefore in the type of photograph they are able to sell. Some supply news photos and journalistic picture stories. Others specialize in documentary and illustrative pictures for editorial and educational publishing markets. There are also stock agencies that sell advertising, animal, glamour, and historic images.

You can probably assume that your stock agency will want 8 x 10 prints on glossy resin coated paper. Double-weight glossy fiber base paper is also acceptable. The agency will file 35mm and larger format color transparencies—not color prints. Every photo should be stamped with your name, copyright notice and captioned. Be sure to indicate if a model release exists.

A word about duplicate transparencies: Most picture agencies stock only original color transparencies. This is because duplicates don't compare in quality to originals. They are grainy, contrasty, and often have a color cast. Reproduction quality duplicates come close to matching the original slide, but are costly. A simple solution is to shoot a lot of pictures when you come across a photogenic situation. If you bracket, make horizontals and verticals, and include a variety of compositions, you should have enough material to cover your own needs and those of your stock agency.

Choosing a Stock Agency

It's not easy to find the right stock agency. There are hundreds of them out there, they're all different, and some are very selective about who they allow to join. Unless you have an inside line on an agency from another photographer, you'll have to research likely candidates before you commit to a contract.

One of the most important considerations is matching the kind of photograph you make to the kind of photo the stock agency sells. If you shoot industry, and the agency sells glamour—nobody is going to make money. You must find out where the agency is at, market-wise, before even approaching them. When there is a correlation between what you do and what they sell, you'll have the advantage of knowing from experience what the stock agency's clients use. Also, your clients are paying you to produce a steady flow of photographs, which are later resold to other clients by your stock agency.

Location plays a role in selecting a stock agency. If you're a San Francisco shooter, a local agency will be able to give you more guidance and feedback than an agency thousands of mile away. Clients the world over, who are looking for photos of San Francisco, will logically call an agency in that city first. If you shoot local scenes, you'll have the advantage of being able to easily supply the latest skylines, as new construction outdates all previous shots. My stock agency, which is in Boston, is always clamoring for pictures of New England, which I am happy to provide.

The size of a stock agency is also important. You don't want to join an agency so small and unproven that it may fail in the near future. At the same time, the largest agencies, with several million images on file, swallow up the work of the beginning freelancer—if they'd ever take one on in the first place. Try to find a stock agency that you feel comfortable with, that does good business, and that will take an interest in your career over the long term.

Breaking In

Approach a stock agency as you would a publication client. Research the basics in the *Photographer's Market* and the *ASMP Stock Photography Handbook* (see References on page 146). Then call for photographer's guidelines or verbal instructions (Yellow Pages: "Photographs, Stock"). Ask what type of client is served by the agency. Find out what the agency likes to see in a photographer and in a portfolio. If you're curious about the operation of the stock agency, ask for a tour. Query about how other contributing photographers are doing, and request a sample contract. When you think this may be the agency to represent you, tailor your portfolio and make the appointment.

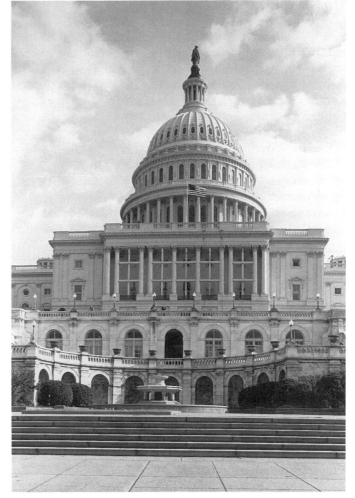

A trend in the stock business is "stock production." Agencies and their photographers methodically target and shoot photos that are in high demand and low supply. Important federal buildings, for example, appear again and again in most government and civics books. Thse structures are concentrated in a small area of Washington, D.C., and can be easily photographed in one or two days. The savvy stock photographer will make a stock photo expedition to the nation's capital, carefully covering all of the landmarks, in black and white and color. These fresh and interesting images, placed in the stock agency's files, will pay off for years to come.

Effective Stock Strategies

When a stock picture agency accepts you, it will take an initial selection of photographs and try to sell them. This is not the time to sit back and wait for the checks to roll in. Like anything else, payback from a stock agency is proportional to the work you put in. If you pursue the following strategies while associated with a stock picture agency, your royalty checks will become constant and sizable.

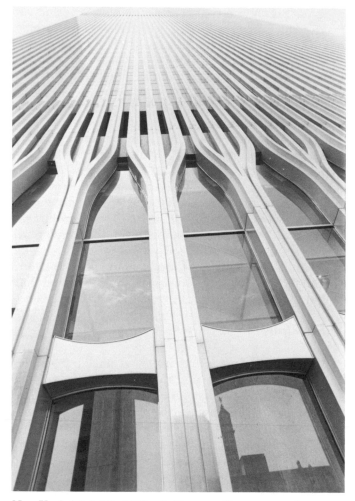

New York City's World Trade Towers offer great stock picture possibilities: when viewed from the ground up or from the open deck at the top. And over a million people pass through the lobbies daily.

- Let the picture research editor have access to every thing. Don't hold back your best shots unless you have a really good reason. Ask if the editor will mark your black and white contact sheets for printing. Otherwise, you'll have to submit prints for consideration. Put your slides into sheets for editing. Submit your most current work first, then move backwards. The agency knows its files, which requests go unanswered, and will fill the gaps with your work. Just because you think a photo has no sales potential, don't assume that your stock agency can't sell it.
- Submit new work every six months. A constant flow of new photographs will increase your stock income.
- Black and white prints must be of first-rate publication quality. If you don't print well, have a good lab make your prints.
- Shoot fine grain "professional" color slide film when ever possible, and have it processed at a quality lab. Use a tripod for these slower films, even when you don't think you need one.
- Model releases, although not required for editorial use, enhance the salability of any photograph. Get them whenever you know the subject. Most agencies ask you to write "MR" on the photo if a release exists.
- Before traveling on vacation or on assignment, ask your agency if they need anything special from that part of the globe.
- When work slows down, go out and produce stock photos. If your agency doesn't publish a tip sheet, they'll be happy to suggest some ideas—you must know the market to know what to shoot. This kind of speculation is fun, profitable, and tax deductible.
- Keep in touch with your agency. Make it your business to know their business. By helping your stock picture agency, you're helping yourself.

Locating Stock Agencies

ASMP Stock Photography Handbook
American Society of Picture Professionals
Creative Black Book
Green Book
Literary Market Place
Picture Agency Council of America
Photographer's Market
Stock Photo and Assignment Source Book
Stock Workbook
Yellow Pages for your local city
Yellow Pages for Manhattan, N.Y.

Client's Viewpoint

Jean Howard
Manager, Research & Editing
Stock, Boston, Inc.
Boston, MA

Stock, Boston would not exist without freelance photographers. And about 5% of freelancers have the specific talents we need:

1. A clear, concise, illustrative style that relates to our markets, which are textbooks and magazines.
2. Technical skills such as exposure, development, printing, and focus. We insist on quality.
3. A productive photographer who shoots a lot on assignment. Nonprofessional photographers shooting for pleasure can be great stock sellers when they have the technical skills and a sustained interest in photography. It takes more than two weeks of vacation slides to get into an agency.
4. A professional attitude is important. Will this photographer stay active? Young photographers with enthusiasm and raw talent can be selected for their potential pictures. I like to see a dual interest in photography and money.

A stock portfolio should have 60 to 200 slides, and 50 good black and white 8 x 10 prints. The slides should be in pages, the prints can be in a box. The selection should represent the photographer's interests and subjects likely to be shot in the future. Basically, I do a market evaluation on the work. The bottom line is: "Will these pictures sell or not?"

Once you decide to get into the stock photo business, take a lot of pictures. When printing up a job, make extra prints of what you think might sell as stock. The return of stock is so slow that a major printing of your life's work would be unfeasible. Photographers at Stock, Boston average over $2.00 per image on file per year. Some photographers, even though otherwise successful, have no quantity of prints to give me. I can't sell a photo I can't show to a client.

Have patience with your stock agency. Be careful not to be too meddlesome, but keep supplying new work and proposing ideas. One of our contributors has been photographing his children as they grow up. The project has paid off handsomely.

Freelancers are always their own best sales representatives, but selling is time-consuming and sometimes a hassle. As an agency, we have clients you can't reach, we're good at selling, and rejection doesn't upset us. There's also an emotional advantage to belonging to a stock agency: We give photographers a sense of purpose—a reason for taking pictures beyond that of the immediate assignment. It's reassuring to know that someone out there will see and possibly buy your work.

Stock agencies are not a panacea for freelancers. Get some experience in the field first, then go to a stock agency. Your regular assignments are the best reason to produce stock photographs. Just think of us as part of your career equation.

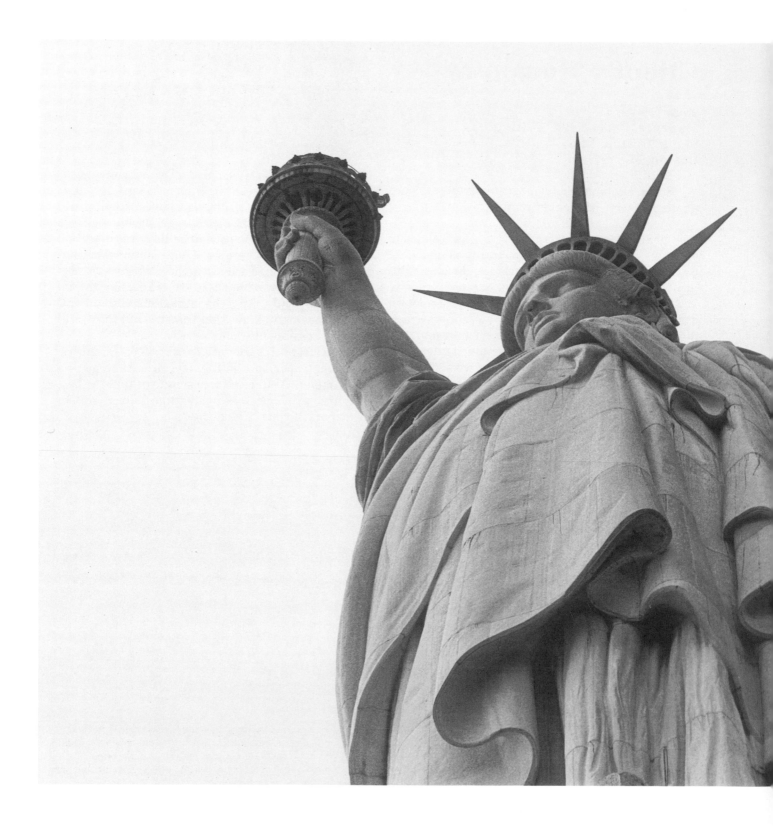

CHAPTER ELEVEN
The Rights You Sell

Know Your Rights

Copyright

Model Releases

It is every freelance photographer's responsibility to be familiar with the laws and customs governing picture sales. Don't rely on clients to interpret your rights for you. Misinformation, whether yours or your client's, can be costly and can disrupt a business relationship.

Know Your Rights

Too many freelancers sweat about not being paid, unauthorized usage, and final ownership of the pictures. They rely on hearsay, or, even worse, bow to clients' demands regarding rights, ownership, copyright, and contracts.

Ignorance can be costly. An East Coast publisher notified all photographers working on a U.S. book project that it would publish the book in another country too. It stated: "Please indicate additional fees, if any." The standard surcharge for a second country is 50 percent added to the U.S. reproduction fee. I charged the client—and the client paid it. Out of curiosity, I asked the book editor how other photographers responded. The range was from no charge to the accepted 50 percent. I suspect that photographers lose more money from their own misinformation than from client rip-offs.

Most disputes you're likely to have over your photos have already been in court. Legal precedent and established industry custom have laid down the law concerning photography. It's every freelance photographer's responsibility to know his or her rights and stick up for them.

The first thing you should know is that all photos belong to the photographer when they are made. The revised copyright law of January 1, 1987, says that pictures are the property of the photographer even if he or she is on assignment for a client. There are only three situations in which ownership of the photos resides with the client: (1) if the photographer, as an employee of the client, takes pictures during the course of employment (does not apply to freelancers); (2) if, prior to or after the shooting, the photographer signs a work-for-hire agreement; and (3) if the photographer specifies on his or her invoice or contract that all rights and copyright ownership are sold to the client.

We have established that under all circumstances, except these three, the photographer is the sole owner of the images. So what does the client get? The photographer sells the client very specific rights to use the photograph. One might say that the photo reproduction rights are "rented" to the client.

The key is knowing what rights to sell and what to charge for them. In general, the more rights you grant to a client, the higher the reproduction fee. Opposite is a table of the most common rights sold, which media they are sold to, and charges.

When you sell a photograph, put the individual rights together and type them onto your invoice. Thus it is clear to all parties exactly what rights have been purchased. My typical textbook rights clause reads: "One-time non-exclusive interior textbook reproduction rights, in English and in the United States, are granted to the photographs listed above." You can modify the clause to fit any media by some simple substitutions.

We see that the extent of reproduction rights sold can determine the price of a photo sale. When a client asks me, "how much?" I must know what usage he or she desires before I can answer. As I mentioned before, financial discussions, including those about rights, should always take place before any work commences.

Most Common Rights Chart

Standard Term	Explanation	Media
One-time	Pins down how many issues or editions a photo may be published in—one! An additional use would require another reproduction fee.	All
Nonexclusive	Clarifies the question of resale. Photographer has the right to resell photo to anyone at any time. Exclusive rights go for at least 200 percent extra. I avoid selling exclusive rights.	All
Interior	Defines placement of photo in media. Exterior, or cover usage, places the photo in a higher pricing range. Size should be specified for each photo in your invoice, as that also determines the price.	All print
Text/magazine/ brochure/TV	Names the media of reproduction.	All
English-language	Specifies the language in which the book will be printed. A foreign language, in addition to English, pays more.	Books
United States	Identifies the area of distribution. North America, Canada, world, or any country in addition to the United States pays extra.	Books

The New York courts built the legal structure around photographic rights. Similarly, the publishing industries and photographers in New York have established standard rates. Photographic law and prices differ in other states. Ignorance of the law is no defense, and not knowing what to charge is poor business practice.

Copyright

Photographers gained ground with the Copyright Act of 1976 and when the United States adopted the international copyright conventions of the Berne Convention in 1989. The formerly gray area of who owns the rights to a photograph is now very clear: the photographer does. Freelance photographers literally own all rights to their pictures the second they snap the shutter. If you haven't given your copyright away by signing a work for hire agreement, no matter who paid for the film or assignment, the pictures are all yours.

Photographers should still take steps to protect their photographs from unauthorized use. The most important thing to do is stamp a copyright notice on all transparency mounts and on the back of all prints. The correct form of copyright notice is:

© 19__ Fredrik D. Bodin

© is the symbol for copyright. The word can be written out and used in addition to or instead of the copyright symbol. The year of first publication or creation appears next, in either arabic or roman numerals. Some photographers prefer the more cryptic roman numerals because they don't want the photograph to appear "dated." A photo does not have to be published to be copyrighted. Last to appear should be the photographer's name. I routinely stamp all slides and prints the moment they cross my light table. A final phrase you may wish to add, "All Rights Reserved," gives double warning against infringement.

The copyright notice, although not strictly required on photographs taken after March 1st, 1989, informs potential users that the copyright to the picture belongs to the photographer. It is a warning that permission for usage must be obtained to reproduce the image legally. If you don't put a copyright notice on your photos, an innocent or unknowing violation of the law occurs from unauthorized usage, and the damages you can collect may be reduced.

A copyright notice is also advisable when your picture is published, especially if the publication itself carries no copyright. Insist on a copyright credit line next to your photos. If your picture should appear in an uncopyrighted publication with no copyright notice next to it, it's put into the public domain.

Actual registration of copyright with the U.S. Copyright Office in Washington is not necessary and is impractical for every picture you take. Register your most valuable images which you feel will need extra protection. You must also have a registered copyright in order to go to court for infringement.

Individual images may be registered, or you can bulk register by copying several or more pictures onto one sheet. In both cases, use Form VA, available from the Register of Copyrights, Library of Congress, Washington, D.C. 20559. A copyright lasts for the photographer's lifetime plus fifty years.

FORM VA

UNITED STATES COPYRIGHT OFFICE

REGISTRATION NUMBER

VA VAU

EFFECTIVE DATE OF REGISTRATION

Month Day Year

DO NOT WRITE ABOVE THIS LINE. IF YOU NEED MORE SPACE, USE A SEPARATE CONTINUATION SHEET.

1

TITLE OF THIS WORK ▼ **NATURE OF THIS WORK ▼** See instructions

PREVIOUS OR ALTERNATIVE TITLES ▼

PUBLICATION AS A CONTRIBUTION If this work was published as a contribution to a periodical, serial, or collection, give information about the collective work in which the contribution appeared. **Title of Collective Work ▼**

If published in a periodical or serial give: **Volume ▼** **Number ▼** **Issue Date ▼** **On Pages ▼**

2

a

NAME OF AUTHOR ▼ **DATES OF BIRTH AND DEATH**
Year Born ▼ Year Died ▼

Was this contribution to the work a "work made for hire"?
☐ Yes
☐ No

AUTHOR'S NATIONALITY OR DOMICILE
Name of Country
OR { Citizen of ▶ _____
Domiciled in ▶ _____

WAS THIS AUTHOR'S CONTRIBUTION TO THE WORK
Anonymous? ☐ Yes ☐ No
Pseudonymous? ☐ Yes ☐ No

If the answer to either of these questions is "Yes," see detailed instructions.

NATURE OF AUTHORSHIP Check appropriate box(es). **See instructions**
☐ 3-Dimensional sculpture ☐ Map ☐ Technical drawing
☐ 2-Dimensional artwork ☐ Photograph ☐ Text
☐ Reproduction of work of art ☐ Jewelry design ☐ Architectural work
☐ Design on sheetlike material

NOTE

Under the law, the "author" of a "work made for hire" is generally the employer, not the employee (see instructions). For any part of this work that was "made for hire" check "Yes" in the space provided, give the employer (or other person for whom the work was prepared) as "Author" of that part, and leave the space for dates of birth and death blank.

b

NAME OF AUTHOR ▼ **DATES OF BIRTH AND DEATH**
Year Born ▼ Year Died ▼

Was this contribution to the work a "work made for hire"?
☐ Yes
☐ No

AUTHOR'S NATIONALITY OR DOMICILE
Name of Country
OR { Citizen of ▶ _____
Domiciled in ▶ _____

WAS THIS AUTHOR'S CONTRIBUTION TO THE WORK
Anonymous? ☐ Yes ☐ No
Pseudonymous? ☐ Yes ☐ No

If the answer to either of these questions is "Yes," see detailed instructions.

NATURE OF AUTHORSHIP Check appropriate box(es). **See instructions**
☐ 3-Dimensional sculpture ☐ Map ☐ Technical drawing
☐ 2-Dimensional artwork ☐ Photograph ☐ Text
☐ Reproduction of work of art ☐ Jewelry design ☐ Architectural work
☐ Design on sheetlike material

3

a
YEAR IN WHICH CREATION OF THIS WORK WAS COMPLETED This information must be given in all cases.
◀ Year

b
DATE AND NATION OF FIRST PUBLICATION OF THIS PARTICULAR WORK
Complete this information ONLY if this work has been published.
Month ▶ _____ Day ▶ _____ Year ▶ _____
◀ Nation

4

See instructions before completing this space.

COPYRIGHT CLAIMANT(S) Name and address must be given even if the claimant is the same as the author given in space 2. ▼

TRANSFER If the claimant(s) named here in space 4 are different from the author(s) named in space 2, give a brief statement of how the claimant(s) obtained ownership of the copyright. ▼

DO NOT WRITE HERE OFFICE USE ONLY

APPLICATION RECEIVED

ONE DEPOSIT RECEIVED

TWO DEPOSITS RECEIVED

REMITTANCE NUMBER AND DATE

MORE ON BACK ▶ • Complete all applicable spaces (numbers 5-9) on the reverse side of this page.
• See detailed instructions. • Sign the form at line 8.

DO NOT WRITE HERE

Page 1 of _____ pages

This is page one of the four page form VA.

Model Releases

Beginning freelancers worry about model releases too much, and for the wrong reasons. They worry about approaching strangers to sign releases, question the salability of their street photography without releases, and hesitate to take pictures freely and attempt to sell them.

For the editorial markets discussed in this book, model releases are seldom required. But it is important from a marketing viewpoint to know that not having a model release will limit your sales. Any picture is potentially more valuable when you have a model release. Also, it is prudent to be aware of the legal implications of picture usage and your liabilities as a photographer.

In some circumstances a photographer might be asked to have a signed model release. First, any photo of a recognizable person to be used for advertising, promotion, or trade should be model released. If a shot of private property is used for advertising, a property release from the owner should be obtained. The Image Bank, a stock agency that does much of its business with advertising agencies, asks its contributing photographers to back up their photos with model releases.

Another model release situation occurs when a photograph containing a recognizable person, even though it may be innocent in itself, is used in a potentially libelous context. If people could make a negative value judgment about the photo and/or its usage, it's preferable to have a release. Take an ordinary head shot of a person, for example. It's harmless enough until it's put on the cover of a drug abuse book. Then, the subject may feel that his or her reputation has been damaged, and the photographer is vulnerable to a libel suit. In cases like this, a model release covering all uses in any media is a must.

A third instance requiring model releases is in the area of possible invasion of privacy. Although your picture-taking rights are protected by the U.S. Constitution, individual rights of privacy will sometimes have precedence. You can sell photos of people taken on the streets, in parks, and in other public places without their permission for non-advertising and non-libelous usages. By being in a public space, your subjects have given up some of their rights of privacy. A person's home, private property, or a clinic or hospital is another matter. Here people have a right to their privacy, and publication of pictures taken of them in any of these places may be deemed an invasion of privacy. Get a model release if you intend to sell these photos elsewhere.

Although a release in not always a legal necessity, some clients and photographers feel that when models are hired, amateur or professional, they may as well have releases signed all around. This is a sound idea, since the models are being paid and the photographer has control of the shoot.

Even if you do not require a model release for an intended usage, it's always better to have one. The freelancer should always insist on using his or her own model release form. If your clients insist on using their forms, which may not cover you, get both signed. That will satisfy the client and you'll have a potentially more salable picture. Remember—having a signed model release helps protect you and increases the stock value of your photographs.

Payment to the model or subject is not necessary in order for a model release to be valid. If your model is a minor, you must have the parent or guardian give their consent at the bottom of the minor release form. If your model is an animal, use a property release form. File your model releases carefully. You'll want access to them as long as your pictures are sold by you, your agency, or your heirs.

Carefully constructed model release forms are published in the *ASMP Stock Photography Handbook* and *Forms* booklet, along with a frank and practical discussion of the issues. ASMP encourages users of these books to adapt their model releases and use them freely. Always be aware, however, that no model release gives absolute protection and that the law may vary from state to state and changes over time. If you have questions about model releases, ask an attorney conversant with this area of the law.

A seemingly innocent photograph could be potentially libelous when used in certain contexts, and the photographer does not have control over what happens when it is at a stock agency or publisher. If this photo appeared on the cover of a book about white-collar crime, a model release would be required.

MODEL RELEASE FORM

In consideration of my engagement as a model, I hereby grant to Fredrik D. Bodin, "photographer," his heirs and assignees (including any agency, client, periodical or other publication), the irrevocable and unrestricted right and permission to copyright, use, re-use, publish, and re-publish photographs of me or in which I may be included, in whole or in part, without restrictions as to changes or alterations, in conjunction with my own or a fictitious name, in any and all media for advertising, art and exhibition, editorial, trade, or any other purpose whatsoever. I also consent to the use of any printed matter in conjunction therewith.

I herby waive any right that I may have to inspect or approve the finished product or products or any other matter that may be used in connection therewith or the use to which it may be applied.

In giving this consent, I release the photographer, Fredrik D. Bodin, his heirs and assignees, from any liability by virtue of alteration, whether intentional or otherwise, that may occur in any publication, sale, or use, including without limitation any claims for libel or invasion of privacy.

I warrant that I am twenty-one years of age, have read the above release, and am fully familiar with the contents thereof. This release shall be binding upon me, my heirs, and assignees.

Date: _____

Name of Model: _____

Address of Model: _____

Witness: _____

Shooting Location: _____

Fredrik D. Bodin • 5 Wiley Street • Gloucester • MA • 01930 • (508) 281-3771

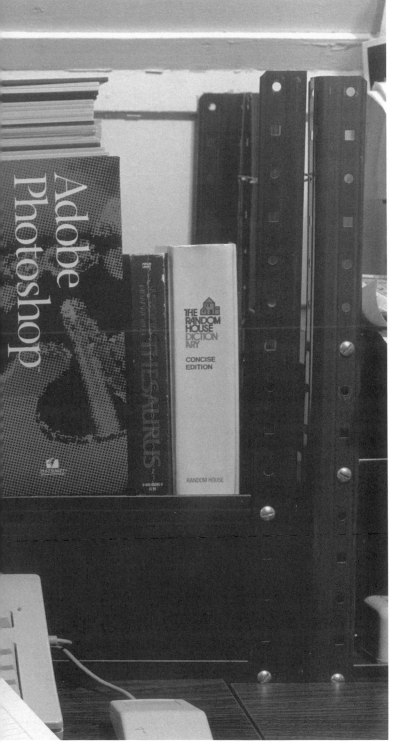

CHAPTER TWELVE
The Photographer's Office

Stationery Components

Invoicing

Business Filing Systems

Office Accessories

Taxcs and the Freelancer

Word Processing Computers

Stationery Components

In order to conduct business, every freelance photographer needs stationery. A printed letterhead imparts credibility, forms insure accurate and complete entry of information, and pre-printed terms notify clients of conditions applicable to the transaction. All correspondence reflects your professional image and advertises your business.

Letterhead

The foundation of a line of stationery is the basic letterhead. It is a sheet of 8 1/2 x 11 paper with your name, address, and telephone number on it. Something in the design of your letterhead should indicate the type of business you're in. The word photographer or a simple photographic logo should suffice.

To have a letterhead printed, you must have a mechanical or finished version ready for reproduction. The cheapest way to prepare a mechanical is to do it yourself using art supplies or a personal computer (see "Logistics" on next page). Some print shops offer design services, or you might get a student or friend to put a mechanical together for you. Look at preliminary sketches until you find one to your liking.

Take the finished mechanical to a quick printer or copy shop. Five hundred copies should cost about $20. If you choose a colored paper for your letterhead, ask the printer to run about a hundred copies on white. The white letterheads will serve as basic mechanicals as you add components to your stationary.

Although your letterhead is intended for written correspondence, it can be used as a simple consignment, invoice, and model release form. Simply type what is necessary onto the blank letterhead. It will soon become evident that having printed consignments, invoices, model releases, and other forms will save time and do the job better: type and draw the needed information onto a white letterhead, and then take the new mechanical to the printer.

Stationery Components (in order of necessity)

Basic Letterhead: Described above. You can get by with this alone for a while.

Invoice: This form is used to bill clients for assignments and stock photo sales. It specifies the terms of payment, rights sold, reserves other rights for the photographer, spells out details concerning loss, damage, return, and model releases. Keep one copy of each invoice in your files for reference and tax purposes. Invoices are discussed later in this chapter.

Business Card: The common business card is a great tool for promotion, client reference, and networking. It must include your name, address, and phone number. There is some room for creativity here—a photo on the card, unusual ink or paper, or printing on a rotary index card. Avoid hard-to-read type and overly busy or cute designs.

Consignment: This is a packing list or record of photographs delivered to a client. Always keep a copy in your files, and update it when photos are returned. Important terms and conditions are detailed on the consignment, including loss, damage, return, and model releases. Consignments are covered in Chapter 10.

Stock List: Alphabetically lists the subjects in your photo file. Make a general stock list first, and later produce focused ones in your areas of concentration. If you shoot complete picture stories or photo essays, publish these on a list. Chapter 10 talks about stock lists.

Model Release: Secures your subject's permission for immediate and future use of photographs (see Chapter 11). Store all model releases in a permanent file.

Envelope: Your name, address, and optional logo are printed onto the face of a legal-size envelope. A pre-printed return address looks much more impressive that a rubber stamped one.

Labels: Adhesive shipping labels with your return address allow you to type the client's address and attach it to large envelopes or packages.

Reminders: Pre-printed reminders diplomatically prod your clients into returning pictures and paying overdue invoices. When you have many outstanding invoices, you may want to send out statements, which are more formalized reminders of how much money you're owed and how long you've been waiting for it.

List of Services: This promotional vehicle tells prospective clients what you can do for them and how much it will cost. You may want to list some of your more impressive clients here.

Logistics:
Making a Mechanical

If you have access to a computer, the entire mechanical can be designed electronically on-screen and printed on a laser printer. Otherwise, pick up a transfer lettering catalog at an art supply or large stationery store. Select a type style and size for your letterhead. Remember that the typeface should be easy to read, not too outlandish, and compatible with the image of your business. Buy a sheet of the typeface in black.

Using masking tape, tack the corners of an 8 1/2 x 11 sheet of white paper to a larger sheet of white paper or cardboard. Determine the approximate base of the line of type by positioning the transparent type sheet. Measure and mark the base line on the white paper with a ruler and light blue ("non-repro blue") pencil.

Burnish or rub on the letters above the blue line. Judge the space between the letters by eye; skinny letters such as "i" will need less space around them. Just move the type sheet around until the spacing looks right. With a little practice, you'll be able to do your own camera-ready mechanical, and you'll probably wish you had a computer.

Basic Letterhead

Envelope

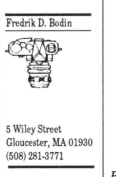

Business Card

Invoicing

In most businesses, including freelance photography, you usually don't get paid until you bill the client. Believe it or not, freelancers suffer cash-flow problems from delayed billing. An efficient invoicing system can save you time and get your money into your bank account, where it belongs.

Design or copy an invoice format suitable for your business. It must have your name, address, and phone number on it, as well as space for the inside (client's) address, the date, purchase order number, and the project title. Below the client and project information, designate columns for (1) description of items; (2) quantity of items sold; (3) unit price per item; and (4) amount of unit price multiplied by quantity. At the bottom of the "amount" column, have a place to enter the sale amount, sales tax, shipping, and total amount.

Leave space below for detailing the reproduction rights you've granted for use of the photograph(s). These rights are tailored to each sale and are typed in when you fill out the invoice.

On the very bottom or back of your invoice, spell out the "Terms of Usage." These conditions are pre-printed onto all invoices. My invoice form, on the right, is simple and straightforward. It can be filled out on a computer screen, or just photocopied and used with carbon paper. I adapted the terms of usage from those of my stock agency and from ASMP publications. I urge you to get a copy of the ASMP Stock Photography Handbook and construct your own invoice form. You should include the following terms:

Rights: Are any rights offered in addition to those typed on the face of the invoice? Usually not.
Payment: Is there a discount for early payment? Is there a penalty for late payment? Check your state laws on interest fees.
Return: Believe it or not, some clients think they don't need to return photos! It's standard to state that "all photographs must be returned."
Loss or Damage: How much will it cost if one of your clients loses a print? Damages a slide?
Model Releases: Protect yourself by stating that no releases exist unless specified by you, in writing, on the invoice. Disclaim and limit your responsibility for action taken against the client for the use of your photo.

Type your invoice in duplicate. One copy goes to the client. Staple the client's purchase order or confirmation letter to your copy. File this under "Accounts Receivable" or "Unpaid Invoices." When payment comes, stamp your copy of the invoice "Paid," staple the check stub (if there is one) to it, and file under "Paid Invoices." Keep these for tax purposes.

Negotiation Through Invoicing

Talking about money can be difficult, and for some people it's nearly impossible. I've found the invoice to be an effective bargaining tool. If a client uses a picture without your permission or reprints without further payment, don't call and yell or threaten a lawsuit—send an invoice. You'll make your point, diplomatically claim your fair share, and not berate your client to the point of alienation. It's better for the photographer to get the money and stay out of court. And it's easier for the client to pay a bill than to lose face.

INVOICE

Client Name: Project:
 Company:
 Street:
 City: State: Zip:

Order Date: Invoice #:
 Due Date: Purchase Order #:
 Ship Date: Ship Via:

Description	Quantity	Unit Price	Amount

Rights Granted: Sale Amount:
 Sales Tax:
 Shipping:

Amount Paid: Total Due:

TERMS OF USAGE

RIGHTS: This invoice offers only the reproduction rights detailed above. Rights to use any photograph are granted only by payment of this invoice. PAYMENT: Payment in full is due in full within 30 days of the invoice date. 1 1/2% per month service charge will be applied to any unpaid balance. RETURN: All photographs must be returned as soon as possible, or upon demand. 4/C (color transparencies) must be returned by verifiable delivery. LOSS OR DAMAGE: Recipient is responsible for loss or damage to these photographs until actually delivered to Fredrik D. Bodin. In the event of loss or damage, recipient agrees that the value of of each color transparency shall be $1,500 unless indicated otherwise next to said item above, and the value of each B/W (black and white print) shall be $35. MODEL RELEASES: No model releases exist on any photo unless specified in writing on this invoice. Where the existence of such release has not been specified, user shall indemnify Fredrik D. Bodin against all claims arising from the use of said photograph. In any event, the limit of liability of Fredrik D. Bodin shall be the invoice price of the photograph.

Fredrik D. Bodin • 5 Wiley Street • Gloucester • MA • 01930 • (508) 281-3771

Business Filing Systems

The purpose of a filing system is to create a place to put things you'll need later, and to allow you to find them again quickly. The best filing system is one that works for you with as little maintenance as possible. This is my system. Parts of it will work for you—customize it to fit your own needs.

Clients: This extremely important file is subdivided into folders for each client I have. You may eventually want to dedicate a file drawer to your clients. Guidelines and Photo Market Analysis go into this file, along with samples, publications shot by you, prints orders, correspondence, and ideas for future projects. When you bid on a job, it might be a while before the project is given to you. Record bids here to avoid misunderstandings. Minor clients can be put into "A - O Miscellaneous" and "P - Z Miscellaneous."

Computer: I keep computer warranties, useful magazine articles, and advertisements for hardware and software I'd like to buy in the future here. The manuals for the computer and software take up so much room that they won't fit in this hanging file folder, and are stored on a bookshelf.

Consignments, Active: When stock photos are at a client's for consideration, the paperwork should be here.

Consignments, Inactive: And when the photos are returned, indicate it on the consignment and keep it in this file for a year. They may want to take a second look.

Data, Exposure: Magazine articles, charts, hints from colleagues, and notes from my own experience go into data files. The next time I have a job requiring special techniques, I consult this valuable resource.

Data, Film & Processing

Data, Framing

Data, Lighting

Data, Printing

Equipment, Darkroom: These files store information on equipment I own. They are repositories for instructions, warranties, accessories, and catalogs. When something breaks or wears out, I go here.

Equipment, Lighting

Equipment, Miscellaneous

Equipment, Office

Equipment, Projection

Equipment, Shooting: I've broken this one down into 35mm, 6 x 7 cm, 4 x 5, and 8 x 10.

Equipment, Video

Expenses: For the breakdown of this file, see "Taxes and the Freelancer," this chapter.

Ideas, Raw: Put notes, interesting brochures, and newspaper and magazine clips here. The idea file can be broken down geographically or by subject.

Ideas, Recycle: A query or story proposal that has been rejected or used by one client can sit here until it is marketed to another client.

Insurance, Business: File photo equipment, office equipment, automobile, and all other business insurance policies here. Your receipt for the premium payment should be filed under "Expenses."

Insurance, Health

Invoices, Paid: I stamp my copy of the invoice "PAID," noting the date and amount paid. I also staple the check stub to the invoice. It's not a bad idea to photocopy all checks.

Invoices, Unpaid

Markets, Educational: Leads and information about clients and markets you'd like to investigate can go here. When work is slow, I delve into these files and try to dig up some work.

Markets, Industrial

Markets, Magazine

Markets, Miscellaneous

Markets, Public Relations

Model Releases: File your signed model releases chronologically. Be sure the photo is described or a photocopy of it is attached.

Retirement Plan

Tax Documents: I keep my employer identification number, sales tax certificates, Social Security number, and other state and federal documentation here.

Tax Forms: State and federal quarterly estimated tax forms, sales tax forms, annual income tax forms, W-2's, and 1099's collect in this file until they're needed.

Vendors, Photo & Processing: I find myself constantly referencing this file for my favorite lab's price list to bid jobs.

Also keep a geographic file for every city, park, state, and country you've ever photographed. My file on France, for example, contains maps, train routes, tourist brochures, and my shooting log. Since my command of French is rather weak, this file is a lifesaver when I need to recollect and confirm spelling for a photo caption. Accurate and detailed caption information increases the value of your stock.

Photocopy the facing page. Cut along solid lines and fold over dotted lines. Put folded tabs into hanging file folder windows, or glue to manila folders.

Clients	Equipment, Miscellaneous	Invoices, Unpaid
Computer	Equipment, Office	Markets, Educational
Consignments, Active	Equipment, Projection	Markets, Industrial
Consignments, Inactive	Equipment, Shooting	Markets, Magazine
Data, Exposure	Equipment, Video	Markets, Miscellaneous
Data, Film & Processing	Expenses	Markets, Public Relations
Data, Framing	Ideas, Raw	Model Releases
Data, Lighting	Ideas, Recycle	Retirement Plan
Data, Printing	Insurance, Business	Tax Documents
Equipment, Darkroom	Insurance, Health	Tax Forms
Equipment, Lighting	Invoices, Paid	Vendors, Photo & Processing

Office Equipment and Accessories

Set up your office to run smoothly and efficiently. Buy office equipment and accessories only as you need them and can afford them. When you start freelancing, your office may consist of the kitchen table and your picture files in the hallway. As your business grows, your office and picture files will require a dedicated room. To shorten the commute, try to keep your office, darkroom, storage, and shooting area close together.

Appointment Book: I won't schedule anything without this book. Each two-page spread covers one week, and days are broken down into hours. I bring it with me when I know I'll be booking a job in a client's office.

Business Card File: When your networking skills cause your collection of business cards to grow, use this inexpensive device to store them alphabetically.

Calculator: You can't live without a calculator, even if you only use it to balance your checkbook. My favorite calculator has big buttons and large numbers.

Coding Dots: Self-adhesive 1/4 inch diameter dots are perfect for marking contact sheets for printing and bringing a client's attention to certain slides. Get shocking neon colors for visibility.

Computer: A dependable and useful computer costs less than a camera and a few lenses. This tool increases and enables productivity in all areas of the freelance photography business. Read more about computers later in this chapter.

Copier: Checks, consignments, invoices, proposals, and many other business documents end up on the copier. I also photocopy black and white pictures and tear sheets to send to potential clients who don't want originals. A quality copier allows you to print your own stationary, stock list, or newsletter as you need them. If you find yourself frequently running to the copy center, it might be time to buy one.

Dictionary: Nothing looks as bad as spelling mistakes in business correspondence. Your clients will never know how often you use it. I keep my dictionary right on the desktop.

File Cabinets: Keep your paperwork and photos organized and safe in baked enamel metal file cabinets. Steer clear of painted metal and wood, which emit fumes harmful to photo emulsions.

Facsimile Machine: This arrival to the office scene has proven useful to photographers. Layouts, photo requests, and purchase orders can instantly appear in your office. You can send out invoices, quotes, signed contracts, and even images on your FAX.

Letter Trays: These stacking trays are useful for organizing paperwork awaiting your attention.

Light Table: My light table is frequently used in my office. I edit and stamp slides before filing them. I research stock requests before consigning and shipping them. Also, visiting clients inspect images on the light table.

Markers: Black permanent markers are good for addressing large envelopes and marking contact sheets.

Paper Cutter: Rotary paper cutters trim prints cleaner than the guillotine type, and are safer.

Postal Scale: I own one for weighing first class mail and one for heavier (up to 50 pounds) packages sent UPS.

Rotary Card File: Stores and allows easy access to frequently used addresses and phone numbers.

Stamps: Name and address, PAID, Photos—Do Not Bend, For Deposit Only, and © 19__ Fredrik D. Bodin.

Stapler: Get a sturdy one for attaching receipts, purchase orders, and check stubs to invoices.

Tape: You'll need masking tape to attach captions to photographs, and clear 2 inch wide packing tape to seal envelope flaps and boxes.

Telephone Answering Machine: Absolutely essential! Whether you're out shooting or lying on the beach, if your client can't connect with you they'll just call someone else. I even got a car phone because I was losing too much work while driving to locations. Most answering machines allow you to remotely retrieve your messages.

Typewriter: All written communication, including consignments and invoices, should come out of a typewriter or computer printer. Some computerized offices have typewriters for the convenience of filling out forms and mailing labels. Seriously evaluate the price difference between a quality typewriter and a good computer—then buy the computer.

WORK ORDER

Fredrik D. Bodin

☐ ASSIGNMENT PHOTO
☐ STOCK REQUEST
☐ PRINT ORDER
☐ OTHER

5 Wiley Street
Gloucester, MA 01930
(508) 281-3771

CLIENT: DATE ORDERED:

 DATE DUE:

PHONE: QUOTE:

SPECIFICATIONS:

ORDER RECORDED BY: ☐ JOB DELIVERED

JOB PERFORMED BY: ☐ JOB INVOICED

Taxes and the Freelancer

Freelance photographers operate what is called a sole proprietorship, otherwise called working for yourself. To be recognized as a business by the Internal Revenue Service for tax purposes, you must show "intent" to make a profit. With the exception of a few states and localities that require licensing, all you need to do to be a professional photographer is start working or start looking for work. You must show a profit three years out of five to continue tax deductions, as defined by the IRS.

The American tax system is designed to encourage business investment and growth. Large and small businesses alike can legally claim their operating and reinvestment expenses as tax deductions. Freelance photographers are entitled to a broad range of deductions, but don't count on the IRS to remind you of the ones you missed. Just as you are responsible to the state and federal governments for knowing your income tax obligations, you are responsible for your own business's well-being by taking full advantage of tax deductions.

One of the joys of freelancing is the financial encouragement received from Uncle Sam. I see a new camera or lens as a wonderful new toy. But it's really a tax deductible tool. I see a travel assignment as an adventurous vacation. And it's deductible, too. The net result is paying fewer taxes in the beginning as your business expands.

Gross Income

Your gross income is the total sum of wages, fees, commissions, royalties, interest, and dividends, from photography and other sources. As a freelancer makes money during the tax year (usually January 1 to December 31), income must be recorded. The IRS insists on it, and it's useful to know how well you're doing as the year wears on. Most photographers record their income in a ledger book or into a computerized ledger. They also enter expenses using the same system. Even though you've recorded income and expense totals in the book, your invoices and receipts must be kept for three years. For tax purposes, only paid invoices need to be reported.

If you prefer not to use a ledger, put paid invoices into a "Paid Invoices" file. At the end of the tax year, add up all of the paid invoices. To that figure, add royalties, commissions, and interest. That's your gross income. If you want to monitor your income, keep a simple monthly tally. Any clear, complete, and accurate method of recording your income is okay with the IRS.

Expenses

The catchphrase of expenses and tax deductions is "receipt and record every nickel." Don't overlook anything! For every $10 in tax deductions you record, $3 stays in your pocket. That's $3 cash that you would have paid in income tax on $10, and taxes are going up. The following are categories for business expenses I incur during the year.

Advertising: Record money spent on print and electronic advertising.

Automotive: All business driving is tax deductible. Either deduct 27.5 cents per mile, plus interest, tolls, and car wash costs. Alternatively, you may total all auto-related costs and apply your percentage of business driving to it. Example: I drove 8,500 miles for business last year and 1,500 miles for nonbusiness reasons. The total operating cost of my car was $5000. I am entitled to 85 percent, or a $4,250 deduction. Typical auto-related expenses are gasoline (get a cash receipt), insurance, taxes, license fees, depreciation, maintenance, repair, registration, tires, tolls, and parking. You must keep a mileage record. Mileage record logs are sold in stationary stores, or you can make your own. Note the date, point of departure, time of departure, mileage at departure, destination, time of arrival, mileage at arrival, miles driven, and the job.

Contract Help: Get a bill from anyone who helps you at work. If you employ someone on a regular basis, they are no longer contract or freelance help, and you may have other tax responsibilities as an employer, including withholding taxes and unemployment insurance. Your tax consultant will explain the precise difference between independent contractor and employee.

Education: All courses, seminars, and workshops that advance your career are deductible. Also claim travel, lodging, meals, and books needed to attend these educational events.

Entertainment: Only 80% of meals and entertainment is deductible. Get a dated receipt and write on it who you entertained, what firm they represent, a brief notation of what your business interests in them are, and what was discussed. Forms of entertainment are meals, drinks, movies, theater, sports events, and hosting. Because the entertainment deduction is often

abused, you should read specific guidelines before any lavish entertaining. Excessive expenditures in this category are frequently investigated.

Gifts: Up to $25 per client per year.

Insurance: All business-related insurance is deductible.

Interest: Fully deductible on business loans and credit card business purchases.

Legal Fees: When they concern your business.

Literature: Write off business-related magazine and newsletter subscriptions. If no receipt is available, use your canceled check.

Materials, Depreciable: Photo equipment, such as cameras, lenses, and tripods, does not get used up, but it does gradually wear out. The IRS wants you to deduct the cost of equipment over its useful life. Most photo equipment is expected to last about seven years. Thus, deduct 14.29 percent of the total cost of a piece of equipment every year for seven years. Under section 179, however, you may expense (claim the full 100% deduction in one year) up to $10,000 annually for equipment purchased during that year. There are various ways to depreciate items; see your tax consultant.

Materials, Nondepreciable: These are items that get used up, such as film, paper, chemicals, and small accessories. Deduct the full price paid for these items.

Office: Stationery, pens, envelopes, and all other photographer's office accessories are tax deductible. Office hardware, such as computers and copiers, must be depreciated.

Postage: Make sure you get receipts from the post office and any other carriers you use.

Public Transportation: Taxi, bus, or commuter flights—get a receipt or make a notation as if it were an auto mileage log.

Rent: Rent is deductible on a pro rata basis according to the square footage or number of rooms used exclusively for business. Example: A four-room apartment has an office in one room and a darkroom in another.

One-half of the rent, insurance, maintenance, and utilities is deductible. Additionally, if you own property, interest and taxes are proportionately deductible.

Retirement: Freelancers must provide for their own retirement. Enroll in a Keogh, IRA, or other retirement plan at a bank or mutual fund company. Contributions to your plan are tax deductible (up to predetermined amounts), and there is no minimum contribution. Interest accrued by your retirement account is not taxed until you retire.

Travel: A business trip is fully deductible. Keep a travel log and get receipts for everything. A trip that is partly for pleasure is deductible on a pro rata basis.

Utilities: Electricity, heat, and telephone bills are deductible when used in connection with your business.

Who Should Do Your Taxes

Do your own taxes only if you're as knowledgeable as a professional accountant. I advise using an accountant to plan for and prepare your taxes. Preparing to see your accountant is crucial. Total your gross income and expense categories. Bring your blank state and federal tax forms. In a few hours, your tax returns will be accurately filled out. It's even possible that your accountant will suggest deductions you hadn't thought of. Your accountant will also be aware of changes in the tax laws. And the cost will probably be under $150.

When to Pay Taxes

If your yearly income tax is under $500, you may pay taxes annually, before midnight on April 15th. If your estimated taxes are over $500, you must pay estimated state and federal income tax quarterly. Use the Declaration of Estimated Tax for Individuals (Form 1040-ES).

Note: This material was accurate to the best of my knowledge at the time it was written. Tax laws change monthly. See an accountant or tax consultant for the latest information on taxes.

Personal Computers

Today's personal computer handles word processing, database management, accounting, graphics, and page layout—all the crucial tasks in the photographer's office. A computer, like a telephone, is a tool that helps you make more money. It saves time and allows you to communicate effectively (sell) with a large number of people.

For most of us, the best computer to buy is an IBM (or IBM clone) or an Apple Macintosh. You can buy a system (computer, keyboard, monitor, floppy and hard disk drives, and dot matrix printer) for under $1,500. Later, you can add a laser printer and other enhancements. Learn how to use your machine by taking classes, if you have to, and you can start using desktop publications to sell more pictures.

Freelance photographers write letters, queries, and proposals to get work. You can write ten times more, and they'll look better, using word processing software on your computer. It's easy to make corrections, spell and grammar check, and print copies in quantity. Requests for photographer's guidelines and recycled story proposals are often repetitive. You can tailor the document on-screen by simply changing the client name and address.

Database management is another useful function of the personal computer. You can store the names, addresses, and phone numbers of hundreds of potential clients. Then, at the touch of a button, you can produce mailing labels, phone lists, and personalized "mail-merge" letters. Database programs can also manage your finances. Invoice forms are filled out on the computer and a copy printed for the client. When expenses are also put into the system, profit or loss can be viewed in seconds. You can also print a list of who owes you money.

A page layout program helps promote your business. Ads, coupons, flyers, stock lists, and newsletters with graphics can all be published right in your office. I use my word processor and layout programs to make price lists, print order forms, letterheads, consignments, invoices, a gallery newsletter, and wedding information sheets. What used to take hours now takes minutes.

Although great advances have been made in capturing and manipulating photographic images on the computer screen, it's not time to abandon your camera and darkroom. The technology exists for magazine-quality reproduction in black and white and in color, but it's still expensive. Stock agencies are already selling photographs on compact disks (CD ROM), encouraging clients to crop, manipulate, and publish right off the disk. This could be the wave of the future for all of us. Right now, freelancers with computers can scan photographs and print them with reasonable quality in newsletters and other promotional publications. And when high resolution technology is within our grasp, I want to be ready.

The computer stock list on the facing page was done on a Macintosh computer. As I made the photographs, I listed them on a database, along with detailed descriptions of each shot. I can now print an alphabetized two column list or catalog with descriptions. Additions and corrections can be made in seconds, without retyping the entire page.

Computer-Related Stock Photographs

Accounting report
Acoustic modem
Bar code
Calendar program, Daily Planit!
CD ROM drive
CD ROM interactive
Coaxial cable
Cursor on IBM screen
Database software packages
Database with photograph
Disk, 3 1/2 inch
DOS Manager
Electronic bulletin board
Expert system
FAX board
Financial information service, Dow Jones
Finder screen
Finder screen and icons
Framework III
Gantt chart
Graphic User Interface (GUI)
Graphics in desktop publishing program
Graphics software packages
Hard disk, half height
Help screen, MacWrite II
Help screen template, WordPerfect
Information utility, BCS
Information utility, Compuserve
Information utility, Compuserve
Information utility, Prodigy
Inserting 5.25" disk into floppy drive
Integrated software
Kapor, Mitch
Keyboard and mouse
Macintosh SE/30 computer
Mail merge
MICR character on check
Microfilm reader
Midas tax assessment software
Motherboard for Apple II

Motherboard for IBM 80386 25 MHz
Mouse, one button
Mouse, two button
Mouse, three button
MS Windows 3.0
Net profit on accounting software
Newspaper desktop publishing
OCR numbers on credit card
PackRat 3.0 organizer and scheduler
Page layout, PageMaker
Parallel port and cable
Pert Chart
Power strip
Processor chip, 80386
Program Manager for MS Windows
Pull-down menu
RAM board, plug-in
RAM on a memory board
Recipe software
ROM chip
Scan of photo as half-tone
Scan of photo as line art
Scanner and Macintosh computer
Screen saver
Serial port and cable
Sidekick Plus
Spinnaker Software
Surge suppressor
Targa Board with paint program
Telecommunications software packages
Telecommuting
Trial balance
Twisted pair cable
Typing program software packages
Venture capitalist
VGA monitor screen
Voice recognition software
VP-Expert software package
WordPerfect templates

Fredrik D. Bodin • 5 Wiley Street • Gloucester • MA • 01930 • (508) 281-3771

References for the Freelancer

ASMP (American Society of Magazine Photographers), 419 Park Avenue, Suite 1407, New York, NY 10016. The most prominent and forceful voice for advertising and editorial photographers. Write for membership details.

ASPP (American Society of Picture Professionals)/Membership, c/o H. Armstrong Roberts, 4203 Locust Street, Philadelphia, PA 19104. Organization of photographers, researchers, agents, editors, and librarians. Write for membership information.

ASMP Forms. Professionally designed photography business forms, contracts, and releases which you may adapt for your own use. There is also useful advice on good business practices and how to use these forms. For any ASMP book, write for the publications list and order form. ASMP, 419 Park Avenue, Suite 1407, New York, NY 10016.

ASMP Stock Photography Handbook. If you're going to shoot and sell stock, this book should be at your disposal. It covers the market, agencies, pricing (helps you set your own prices), forms, copyright, and more. See address above.

Dress for Success, by John T. Molloy (New York: Warner Books, 1984). The psychological impact of what we wear in the business world is shown to be more important than we think.

Executive Jobs Unlimited: Updated Edition, by Carl R. Boll (Macmillan, 1980). How to write a resume and get the job you want. This material translates to freelance photographers looking for clients.

The Guilfoyle Report, 142 Bank Street #GA, New York, NY 10014. A quarterly newsletter packed with in-depth articles on photography issues, markets, and listings of what major photo buyers are looking for. Although the focus is on nature and natural science, almost any editorial shooter can benefit from the Guilfoyle Report. Write for free information.

How to Win Friends and Influence People, by Dale Carnegie and Dorothy Carnegie (New York: Pocket Books, 1981). This classic describes the sales and management attitudes used by some of the most successful business people in the world. Required reading for all freelancers.

The Linked Ring Letter, published by The Photographic Arts Center, 163 Amsterdam Avenue #201, New York, NY 10023: "The newsletter for photographers who exhibit and sell fine art photography." The letter is short, but offers good thoughts on how to make it in a very tough field.

Negotiating Stock Photo Prices—Seller's Guide, by Jim Pickerell (Pickerell Marketing, 110 Frederick Avenue, Suite A, Rockville, MD 20850; (301) 424-2455. Pickerell's booklet provides a starting point for determining stock photo prices. He states that the fees suggested in his book provide a framework to get you into the ballpark. I agree—everyone needs some sort of reference when trying to price a stock sale to an unfamiliar market. Write or call Pickerell for information.

Photographer's Market, edited by Stan Marshall (Cincinnati: Writer's Digest Books, published annually—use current year). The most comprehensive and organized listing of stock and assignment photo buyers.

Photojournalism: The Professionals' Approach, by Kenneth Kobre (Boston: Focal Press, 1991). Kobre's is still the top photojournalism how-to book. It offers practical advice on how to shoot news, features, sports, and essays.

PhotoSource International, Pine Lake Farm, Osceola, WI 54020: The four marketing newsletters offered by PSI cover the gamut—from beginning freelancer to seasoned pro, from monthly to twice daily. All list photo buyers, what they're currently looking for, and how much they're willing to pay. Most needs are editorial. Solid leads appearing in these publications can be developed into regular accounts. Write for samples and information.

ResumExpert, by A Lasting Impression, 49 Thornberry Road, Winchester, MA 01890. If you have a Macintosh or IBM computer, this software helps write your resume. It contains dozens of resume formats to be used with Microsoft Word. All forms are easy to customize. The manual addresses important issues such as cover letters, resume formats, and overcoming obstacles.

Resources for the Freelancer

Calumet Carton Company, 16920 State Street, South Holland, IL 60474. These heavy duty mailing flats for prints and slides prevent bending damage. Folding cartons are also available. Free price list.

MWM Dexter, 107 Washington Avenue, Aurora, MO 65605. Printer of post cards, brochures, and calendars which uses photographers as sales force on commission. Write for free sales kit.

Frame Fit, P.O. Box 8926, Philadelphia, PA 19135. Metal frames at great prices, especially in quantity. Free price sheet.

Light Impressions, 439 Monroe Avenue, Rochester, NY 14607. Archival supplies for image storage and framing. Free catalog.

Mail Safe, 4340 West 47th Street, Chicago, IL 60632. Thinner, but less expensive mailing flat which sometimes needs a cardboard stiffener. Free price list.

MEI/Micro Center, 1100 Steelwood Road, Columbus, OH. The cheapest computer supplies I've found—disks, labels, ribbons, surge suppressors,—and more. Free catalog.

University Products, 517 Main Street, Holyoke, MA 01041. Archival storage, restoration, and framing supplies. Also many interest tools and furnishings. Free catalog.

Yankee Glass, Old Chester Turnpike, Suncook, NH 03275. Wholesale distributor of mat board, glass, and other framing supplies at rock-bottom prices. Free delivery in New England area. Write for catalog.

Index

Books from Amherst Media

Basic 35mm Photo Guide
Craig Alesse

For beginning photographers! Designed to teach 35mm basics step-by-step — completely illustrated! Features the latest cameras. Includes: 35mm automatic and semi-automatic cameras, camera handling, f-stops, shutter speeds, composition, lens & camera care. $12.95 list, 9 x 8, 112 p, 178 photos, order no. 1051.

Don't Take My Picture!
Craig Alesse

How to photograph family and friends for the point & shoot photographer! Over 100 photos. Features: how to point & shoot your camera, how to get great shots, snapping fantastic group shots, photographing celebrations and special times, taking self-portraits, jump shots, special portraits and more. $9.95 list, 6 x 9, 104 p, order no. 1099.

The Art of Infrared Photography
Joseph Paduano

A complete, straightforward approach to B&W infrared photography for the beginner and professional! Includes a beautifully printed portfolio! Features: infrared theory & precautions, use of filters & focusing, film speed & exposures, night & flash photography, developing, printing & toning. $17.95 list, 9 x 9, 76 p, 50 duotone prints, order no. 1052.

Build Your Own Home Darkroom
Lista Duren & Will McDonald

This classic book shows how to build a high quality, inexpensive darkroom in your basement, spare room, closet, bathroom, garage, attic or almost anywhere! Full information on: darkroom design, woodworking, tools & techniques, lightproofing, ventilation, work tables, enlargers, light boxes, darkroom sinks, water supply panels & print drying racks. $17.95 list, 8 1/2 x 11, 160 p, order no. 1092.

Into Your Darkroom Step-by-Step
Dennis P. Curtin

The ideal beginning darkroom guide. Easy to follow and fully illustrated each step of the way. From developing your own black & white negatives to making your own enlargements. Full information on: equipment you'll need, setting up the darkroom, developing negatives, making proof sheets & enlargements, special techniques for fine prints. $17.95 list, 8 1/2 x 11, 90 p, hundreds of photos, order no. 1093.

Big Bucks Selling Your Photography
Cliff Hollenbeck

A must reference for any pro or beginner. Packed with information from a successful pro. Features: setting up a profitable business, what kind of photography sells, successful portfolios, stock images, planning your business, computerization in your business, plus samples of agreements, contracts, releases and more! $14.95 list, 6 x 9, 336 p, order no. 1177.

Make Money with Your Camcorder

Kevin Campbell

A complete guide, fully illustrated with over 100 photos and diagrams. Completely up-to-date with the latest techniques and equipment. Includes: the business of video marketing, how to get started and where the money is, equipment, editing, how to buy equipment. Also includes a full set of business forms, such as invoices, releases, storyboards, shot sheets & more! $17.95 list, 8 1/2 x 11, 160 p, order no. 1125.

The Wildlife Photographer's Field Manual

Joe McDonald

The classic, inclusive reference for every wildlife photographer. Complete technical how-to, including: lenses & lighting, blinds, exposure in the field, focusing techniques and more! Tips on sneaking up on animals and special sections on close-up macro photography, studio and aquarium shots, photographing insects, birds, reptiles, amphibians and mammals. Joe McDonald is one of the world's most accomplished wildlife photographers and a trained biologist. $14.95 list, 6 x 9, 208 p, order no. 1005.

The Freelance Photographer's Handbook

Fredrik Bodin

A complete and comprehensive handbook for the working freelancer (or anyone who wants to become one). Full of how-to info & examples, along with tips, techniques and strategies both tried and true & new and innovative. Chapters on marketing, customer relations, inventory systems and procedures for stock photography, portfolios, plus special camera techniques to increase the marketability of your work. $19.95 list, 8 1/2 x 11, 160 p, order no. 1075.

Camera Maintenance & Repair

Thomas Tomosy

A step-by-step, fully illustrated guide by a master camera repair technician. Sections include: general maintenance, testing camera functions, basic tools needed and where to get them, accessories and their basic repairs, camera electronics, plus numerous tips on maintenance and repair. $24.95 list, 8 1/2 x 11, 160 p, order no. 1158.

McBroom's Camera Bluebook

Michael McBroom

A totally comprehensive annual with price information on: all 35mm cameras, medium format cameras, view cameras, exposure meters and strobes. Pricing info based on the condition of the equipment. Designed for quick and easy reference. A must-have reference for any camera buyer, business person or collector! Includes the history of many camera systems. $24.95 list, 8 1/2 x 11, 224 p, order no. 1263.

Infrared Nude Photography

Joseph Paduano

A stunning collection of natural images with wonderful how-to text. Over 50 rich duotone infrared images. Photographed on location in the natural settings of The Grand Canyon, Bryce Canyon and the New Jersey Shore. $18.95 list, 9 x 9, 80 p, over 50 photos, order no. 1080.

Basic Camcorder Guide

Steve Bryant

For everyone with a camcorder (or those who want one)! Easy and fun to read. Packed with up-to-date info you need to know. Includes: which camcorder is right for you, how to give your videos a professional look, tips on caring for your camcorder, plus advanced video shooting techniques and more! $9.95 list, 6 x 9, 96 p, order no. 1239.

Underwater Videographer's Handbook

Lynn Laymon

Called *"...required reading...sound how-to information that can be used by both novice & experienced videographers,"* by *Dive Training* magazine, and *"an extensively illustrated, comprehensive guide to underwater video!"* by *Camcorder* magazine. This book, by accomplished diver, instructor and underwater videographer Lynn Laymon, will show you how to get started and have fun shooting your own professional-quality underwater videos! Fully illustrated and packed with step-by-step instruction on: basic & advanced underwater techniques, video dive planning strategies, evaluating & purchasing equipment, underwater composition & lighting, video editing & post production techniques, shooting underwater video at night, marketing your underwater video skills and much more! $19.95 list, 8 1/2 x 11, 128 p, over 100 photos, order no. 1266.

Ordering & Sales Information:

Write Amherst Media for a free catalog of over 200 books and videos about photography and videography.

Dealers, distributors & colleges: Write, call or fax to place orders. Phone/fax 716-874-4450. For price information, contact Amherst Media or an Amherst Media sales representative. Net 30 days.

Individuals: If possible, purchase books from an Amherst Media retailer. To order direct: Send a check or money order with a note listing the books you want and your shipping address. U.S. & overseas freight charges are $2.50 first book and $1.00 for each additional book. New York state residents add 8% sales tax.

Prices are in U.S. dollars. Payment in U.S. funds only.

All prices, publication dates and specifications are subject to change without notice.

Amherst Media, Inc.
418 Homecrest Drive
Amherst, NY 14226 USA
Phone/fax: 716-874-4450